Encountering Art

Different Facets of the Esthetic Experience

Encountering Art

Different Facets of the Esthetic Experience

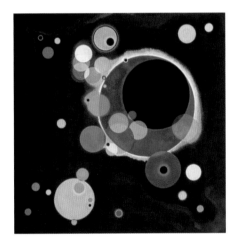

MIHO
MUSEUM

A Publication of the Miho Museum

THE OVERLOOK PRESS
WOODSTOCK & NEW YORK

Designed and Produced by Ruder·Finn, Inc
Creative Director: Michael Schubert
Art Directors: Lisa Gabbay and Gail Garcia
Editor: Dena Merriam

First published in the United States in 2001 by
The Overlook Press, Peter Mayer Publishers, Inc.
Lewis Hollow Road, Woodstock, New York, 12498
www.overlookpress.com

Printed and bound in Iceland.

ISBN: 1-58567-165-7

Contents

Preface
Hiroko Koyama 6

Introduction
David Finn 10

Stones Are My Teacher
Lika Mutal 22

Encounters with Art
Thomas M. Messer 38

About the Art of Looking
Gabriele Czöppan 50

The Heart Shall Be Weary and Wonder
Ronne Hartfield 66

Standing in the Way of Beauty
Kenneth Baker 78

Ancient Fragments Inspire a Career
Yutaka Mino 90

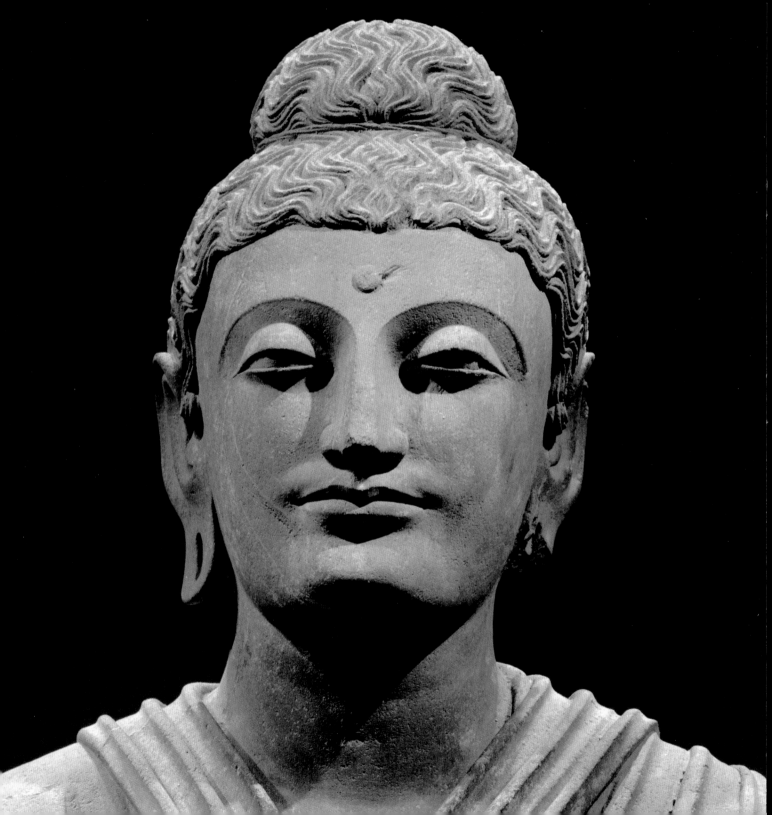

Preface

by Hiroko Koyama

The essays in this book were presented at an international symposium entitled *Encountering Art: Different Facets of the Esthetic Experience*, which was held at the Miho Museum in November 1999 in honor of the second anniversary of the museum's opening. Our goal in organizing this symposium was to explore the impact the experience of art can have on our lives. It is our belief that art can greatly enrich and enhance the quality of life and bring a deeper appreciation and understanding of our inherent spirituality. The beauty we find in art brings us into contact with ideals that can inspire us toward a greater good. It can move us to discover untapped inner resources and a deeper purpose. The power of art is great, and part of the mission of the Miho Museum is to encourage and assist the public to realize its great potential.

We invited an international panel of well-known experts from various fields in the world of art to participate in the symposium and to discuss their personal and professional encounters with art. We wanted to ensure that many perspectives were represented and so we included on the panel leading museum directors, art journalists, an art educator, an art photographer and an artist. Each addressed his or her inner responses to different artistic experiences.

STANDING BUDDHA
Pakistan, Gandhara
Second half of the 2nd century A.D.
Schist
Miho Museum
Shigaraki, Shiga, Japan
Photo: David Finn

My own encounter with art began at an early age. My mother, Mihoko Koyama, for whom the Miho Museum is named, had learned to treasure the beauty in art from her great teacher, the philosopher and art connoisseur Mokichi Okada. He taught that art has the ability to transform the human being and elevate the human consciousness. Art, he once said, "plucks at the soul of all mankind." It moves us as few other experiences do. It can reveal to us a vision of a greater world toward which we can aspire. This philosophy had a great influence on me as a young girl and affected the course of my life.

I had the great gift of not only growing up in a household where art was very much appreciated and collected, but also of working closely with my mother to build the collection of the Miho Museum. Although I had studied art while in college, it was the process of selecting pieces for the museum that enabled me to understand the impact of individual works of art.

Some of the works, when brought to me for consideration for the museum, would leave a profound imprint, and I would know that these were objects of exceptional quality. I learned to see not just with my eyes, but to feel the greatness in the artwork. I learned that art can be intuitively known, not just with the mind, but with one's whole being. Through this process I discovered that many of the artworks had an almost living quality. An exchange developed between us.

I have had such personal encounters with many of the artworks in the Miho Museum collection. The large Standing Gandhara Buddha is one that has been a presence with me since I first set eyes on it, and it never fails to move me when I stand before it. As I walk through the galleries of the museum, I am conscious of the experiences I have had with many of the objects, mindful of their history and of all the people who have stood before them, touched in some way by the artistry that created them.

It was my hope, with this symposium, to provide a forum to consider the role art plays in our lives; to think how we might deepen its impact and use the inspiration to enhance not only our own lives, but the lives of those around us. ✦

Introduction

by David Finn

There are few places in the world that are as fine a setting as the Miho Museum for a symposium on "Encountering Art." In this architectural masterpiece designed by I.M. Pei, with its superb site on top of a mountain, accessible only through a curving tunnel and over a stately bridge, one's mind and spirit are uniquely attuned to an encounter with great works of art. Works in the museum are carefully placed in each gallery almost like stones in a Japanese garden, and they all can be seen with the benefit of special lighting that brings out their finest qualities. The whole experience is truly exalting.

Here one doesn't need detailed descriptions of individual works of art in order to be profoundly moved. One needs only to let one's eyes be openings through which one's heart and mind can be uplifted. Encountering great works of art in such an environment is one of the most spiritually as well as esthetically inspiring experiences one can have.

For me it is reminiscent of other unforgettable encounters I have had in different parts of the world.

About 20 years ago, I embarked on an unusual adventure to photograph Henry Moore sculptures in a variety of landscapes

around the world. Moore, one of the most celebrated sculptors of the 20th century, loved the idea of his works being seen under an open sky with nature as a background. In the 1950s, the idea of sculpture parks came into being, and Moore's works were almost always considered ideal for those settings. In time, his works also became sought-after for urban environments — in front of museums, city halls or other major buildings. In time, there were more Moore sculptures in open air environments than those of any other artist.

Henry Moore was a good friend of mine, and I had published a book with more than 100 photographs of one of his sculptures that my wife and I owned. I had taken the photographs just to show Moore how much we appreciated having this work in our garden, and he urged me to make them into a book, as a way to show people how to look at sculpture. Harry Abrams, the art book publisher, loved the idea and he published the book, together with words from the poet Donald Hall to accompany the photographs. It was appropriately entitled *As the Eye Moves,* and I think it did show people that looking at a sculpture could be an exploration, as one walks around it and discovers an almost endless number of details that are beautiful to look at.

Then one day Moore was in New York, and he and Harry Abrams and I had lunch to talk about other books we might do together. Moore explained his feeling that a sculpture should be seen from different angles in order to be appreciated, and also that when looking at it one should not only pay attention to the forms but to the spaces around them. He thought this was particularly important with sculptures located outdoors, where one's visual experience would include the sky above as well as the forms of the landscape in the background. Moore, like most artists whose works were cast in bronze, usually

made six casts of each sculpture, and he felt that although they were identical, they would produce varied experiences in different settings. I was intrigued by his thought and wondered if I could demonstrate the interaction between his sculptures and the environment in which they were placed by photographing them in different locations. Harry Abrams said that if I would be willing to travel around the world to demonstrate Moore's idea, he would publish a book to be called *Henry Moore, Sculpture and Environment*. I thought it was a wonderful challenge, as did Moore, so over the next several years I photographed Moore sculptures in 51 cities in 14 countries for the Abrams book.

Of course, Moore was right, and my photographs showed how views of each of the sculptures were affected by the environment around them. Seeing one of his sculptures emerging from a heavy fog in Arnhem, Holland was very different from seeing another sculpture glowing in the autumn sun in Göteborg, Sweden and seeing still another sculpture against a sky of scattered clouds in Adelaide, Australia. One of the most dramatic sites for a Moore sculpture was the Open Air Museum in Hakone, Japan, where a great Moore sculpture was sited against a magnificent landscape of mountains and valleys. The idea that I had come to Hakone to photograph that sculpture was so intriguing that a television film was made by Fuji Television of me while I moved around the sculpture with my camera to capture the interaction between this monumental work of art and its beautiful surroundings.

But the most exhilarating experience I had in my travels around the world to photograph Moore's sculpture was when I climbed a great hill in Shawhead, Scotland, to see his masterpiece, the *King and Queen*, sitting on a primitive throne and overlooking what appeared to be the vast lands of their kingdom. I felt it

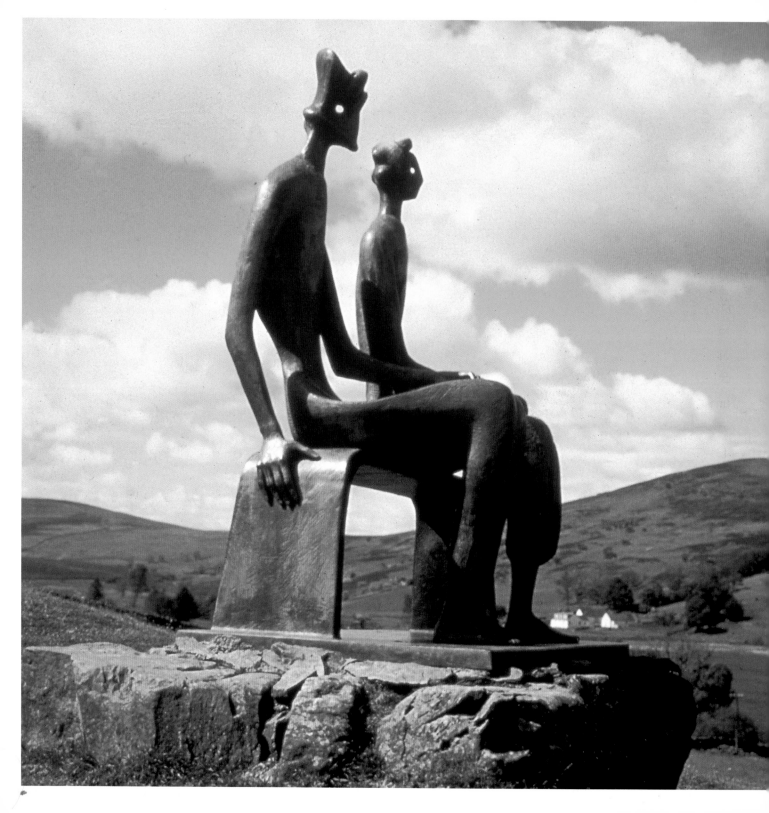

was an experience of a lifetime to be there and to have a chance to study the mysterious forms of those regal figures in such a magnificent landscape. The sculptures were acquired by a collector who had a vast sheep farm of some 3,000 acres—with hills and valleys and a large lake on his land. The *King and Queen* was placed on the highest promontory of the farm, and one could see views of unspoiled nature for miles around. It was mounted on a mound of rocks and looked as if it had been there for thousands of years. This was Moore's own favorite place for the siting of one of his works, and when I was there I could see why. In fact, I traveled to Scotland several times after that first visit just to see the *King and Queen* on that extraordinary site.

I had an equally moving experience when some years later I traveled up the Nile River to see the ruins of the temple at Karnak and photograph some of the sculptures located there. I had been asked by a major publisher if I would be willing to go to Egypt and photograph the masterpieces in different locations for what he believed would be the first book to show these ancient works as great sculptures rather than as archeological finds. The book would be co-published by the British Museum, which had its own fine collection of Egyptian sculpture. The idea intrigued me, and I made several trips to photograph the works in the National Museum in Cairo as well as in Luxor and Karnak. When I focused my camera on these works I discovered how great they really were, and it was thrilling to have an opportunity to reveal their magnificent qualities through the multiple photographs I took of each sculpture.

One of the high points of that adventure was photographing two marvelous sculptures in the open air amidst the ruins of the temple at Karnak. They were of the god Amun and his consort, Amunet. The face of the god was quite wonderful, but his body was gone.

KING AND QUEEN
Henry Moore
1952-1953 Bronze
Glenkiln, Shawhead,
Dumfriesshire, Scotland
Photo: David Finn

However I was astonished when I was able to look closely at the subtle forms of the goddess Amunet. The bright Egyptian sun revealed stunning fragments of the beautifully carved surfaces of her figure, and I felt it was as magnificent today as it had been some 3,500 years ago when it was created. How unlike she was to the fragmented Egyptian sculpture described in Shelley's sonnet, *Ozymandias*, in which the "shattered visage" of a king whose "frown and wrinkled lip and sneer of cold command" was all that was left of a once powerful but now forgotten ruler who imagined that his glory would last forever. Amunet's beauty was still with us, and I was grateful for the opportunity to show it to the world through my photographs. But as Shelley's poem described so eloquently, Ozymandias's fame was long gone.

A third incredible encounter with an amazing work of art occurred when I was invited to take the photographs for a book on monumental Greek bronze sculptures of the 5th and 4th centuries B.C. Most of these were in the National Archaeological Museum in Athens, and it was thrilling for me to be able to photograph sculptures that I had long admired as being among the greatest of all time. I had been to Athens quite a few times on various projects, and I loved the monumental "kouroi" figures that combined both primitive and sophisticated features of the human body. They seemed to make an extraordinarily powerful statement about the sheer beauty of youthful masculinity. And then there was great *Artemision Poseidon*, with his arms outstretched —a breathtaking rendering of a nude male god with a perfect physique. And there were other great figures in the museum—including the famous *Horse and Jockey of Artemision*, with the anatomy of the figures rendered so precisely that one could see the veins in the horse's legs, a number of portraits, and several female figures with garments flowing gracefully around their bodies.

AMUNET,
CONSORT OF AMUN
Egyptian, Dynasty 18
circa 1323-1319 B.C.
Limestone
Thebes, Temple of Karnak
Photo: David Finn

16

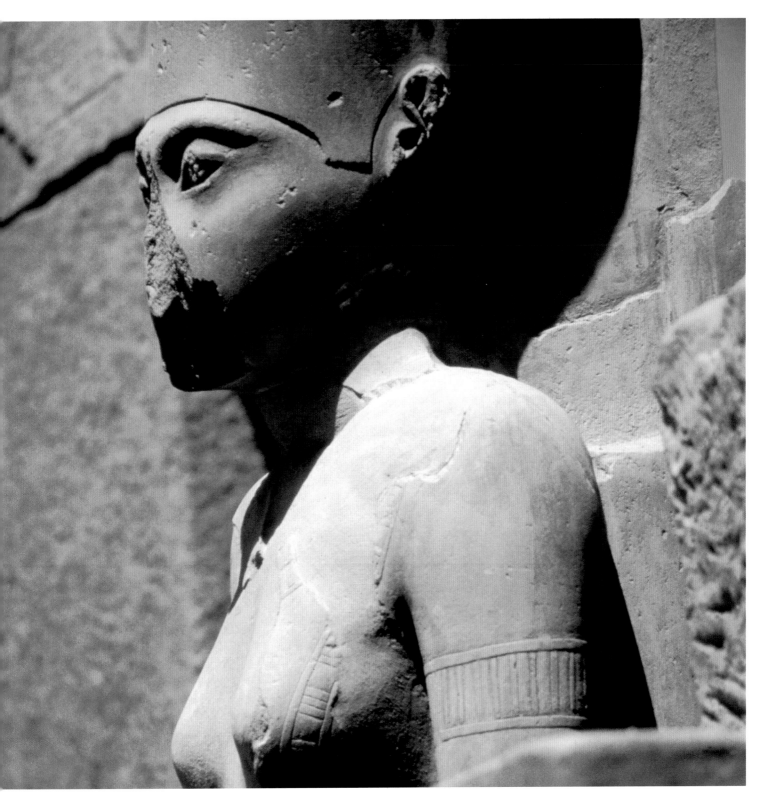

But the apex of my Greek experience was my trip to Delphi. I was awestruck when I stood high up in the mountains where the remains of the ancient temple once featured the oracular message "Know thyself," repeated by Socrates as the ultimate injunction from the gods to mankind. And then, inside the small museum nearby came what I can only describe as a revelation — the sight of the magnificent *Charioteer*, one of the greatest sculptures of all time. Even at first glance, the sculpture was breathtaking, and as I looked at it closely I began to feel that every part of it was magical. The creases of his garment, from the way it flowed over his upper arms to the way the folds formed as they fell to the lower part of his body, were like the notes of a great musical composition. No fold was like another, and together they made harmonies that I could almost hear as well as see. Even his feet, shown just below his garment, were amazingly rendered; looking closely at them

through my camera lens I became conscious for the first time that one's inside ankle is higher than one's outside ankle. It was as if the sculpture taught me things about the human figure I had never known before. I could not stop looking at the unbelievable details of his eyes with their long eyelashes, his classical nose, his full lips, his firm chin—all part of an heroic figure whose perfect form would forever ennoble mankind. It was worth traveling halfway around the world just to be in the presence of this incredible work of art.

You will hear stories of different kinds of experiences from the other participants in this symposium. Our purpose is not simply to exchange stories but to help others look at and see works of art with new insights, as our teachers have done for us.

My teachers have to a large extent been the sculptors who created the works that I have photographed over the past 40 years. Because I have looked through my camera

THE CHARIOTEER
Early Classical,
circa 477 B.C.
Bronze
Delphi Museum, Greece
Photo: David Finn

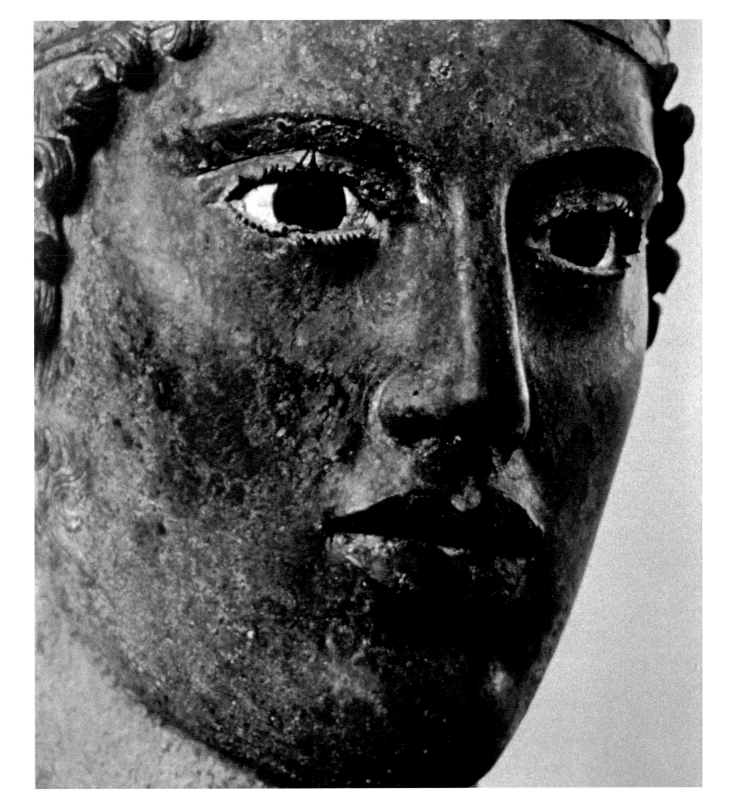

lens at their sculptures from every angle and at every detail, my eye was able to study closely what they had created. By learning how beautifully they had designed their forms, my inner being was enriched, and I felt that their esthetic and spiritual vision was living on within me as well as in the prints I made of photographs of their works.

But my special teacher, the one who had the single greatest influence on my life in the arts, was a German art historian and psychologist named Ernest Zierer, who escaped to the United States during the Nazi era. My mother met him when he was lecturing at the Metropolitan Museum in New York and later introduced me to him. I was 19 years old at the time, and I studied with him until his death some 25 years later, in 1965. He had developed an original theory about art and life that proved to be very difficult for him to explain, and one of my goals in life was to help him communicate his ideas. Although he wrote many books and articles, and I even wrote a book about him myself, I have so far failed to explain adequately the profound meanings of his theory. It had to do with the way we integrate our experiences in the course of our daily life into an organic whole, and how this process in our mental life is expressed in works of art — painting, sculpture, architecture, music, literature. He developed a unique method through which he could teach artists to strengthen their integrative capacities, and he adapted his theory to help patients in a mental hospital whose inner lives had been disturbed by their psychological problems. I think that Ernest Zierer will someday be recognized as one of the most original and significant thinkers of the 20th century, but today he is still relatively unknown. His teachings are with me whenever I look at a work of art, but I feel I am in his presence every morning when I ring the chimes of his 150-year-old pocket watch, given to me by

his wife after he died. It is almost a spiritual ritual for me, in which I can thank him for his gift to me and reaffirm my faith in the importance of his ideas.

I have devoted much of my life as a photographer to trying to show others the discoveries I have made looking through my camera lens inspired by what I have learned from the sculptors whose work I photographed, as well as by Ernest, who taught me to look at the world in his special way.

I have also written books to describe what I have tried to express through my photographs. But ultimately I feel there is no substitute for being with someone in front of a work of art and pointing out the elements that touch one's soul. Somehow the personal contact with others, using my voice to express the emotions one feels, showing in my gestures the excitement I feel when looking at details, is the most effective way for me to convey to others what I find so inspiring.

Stones Are My Teachers

by Lika Mutal

Deep in the earth in the Andean cordillera stands a stone sculpture. It is about 14.75 ft. (4.5 m.) high. The age of the stone is as old as the world. As a sculpture it is only a couple of thousand years old. In order to see it one has to travel to Chavin in the Andes 3.150 meters high and find one's way through an archeological site that includes a labyrinth built at the confluence of two rivers. The nexus point is called Tinkuy, which means balanced harmony in Qechua.

At Eastertime, 1977, I set out for Chavin with a group of friends. We drove 120 km. in seven hours, ascending to 4.000 meters when the road came to an end in front of a steep wall of rock. An uninviting hole in the mountain would permit the passage of only one vehicle at a time. The tunnel was pitch dark, and as we drove through it we felt as if the mountain was engulfing us. At the end of the deep darkness an eye of light appeared and when we emerged, the sense of light and beauty of the earth was overwhelming. On the other side of the mountain the dirt road, still wet from the winter rains, sloped down, giving us an open view of valley after valley. Finally at the end of the afternoon we arrived at the main ruins of one of the oldest cultures

in Peru. The sun hiding behind the mountains cast a shadow over the valley and the temperature quickly fell to near zero. We were happy and relieved to have arrived, after a trip mostly in silence over a slippery dirt road, along abysses and crossing precarious bridges. The views along the way had been impressive, reminding us how insignificant one can feel in the Andean landscape.

At that time there were no closing hours on the site. There was no museum either. Except for a single guard there was no one there and whatever was left of the original architecture was all in relation to the tall stone standing like a seed in the darkness of the earth.

A corridor sloped downwards and narrowed into a small passage that enabled one person to go through at a time. At the end of the passage one stood alone in front of an enormous monolithic sculpture in half shadow rising from the earth, the upper part

LANZÓN DE CHAVIN
circa 2,000 B.C.
Chavin, Peru
Photo: Javier Silva

of which extended into an opening in the roof towards the light. The confrontation with this mysterious object was awesome, more so after the grueling trip.

The enormous stone stood in the center of four narrow passages. It was an intimate space in the form of a cross aligned with the four directions. One could see each side of the stone only by backing away as in the presence of a royal personage and disappearing into the dark—and how dark it was! Then one could move to another passage and approach the stone from a different direction. It seemed like a ritual for the cycles of the earth.

The stone in this place was of such power and made so much sense as a form that it took awhile to become aware of the incised carvings that, like a weaving, were wrapped around it. Animal and human features were interlaced, forming the image of a deity that represented the Andean trinity, the condor the puma and the serpent and connecting

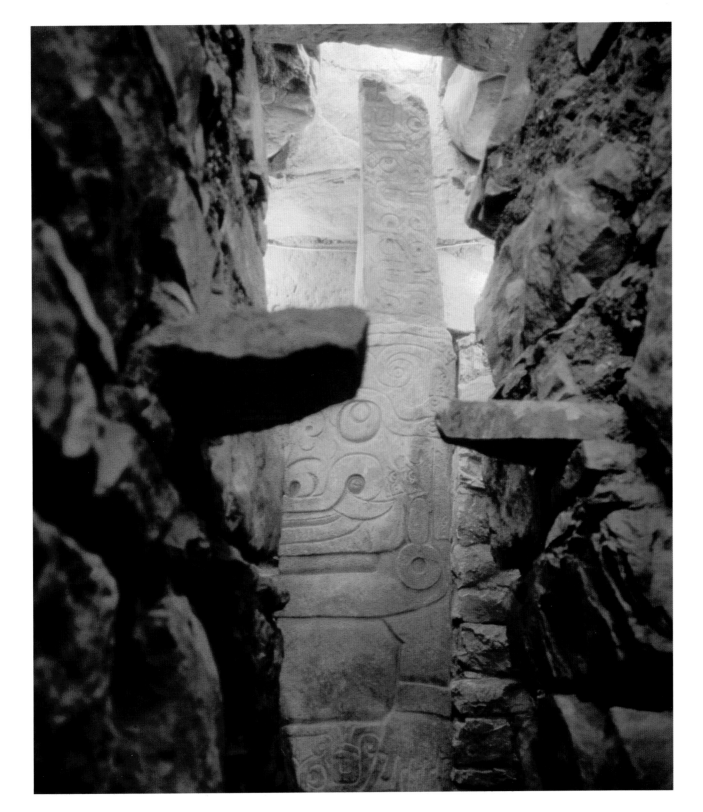

with the three worlds of heaven, earth and the inner earth. What caught our attention were the circles all over the stone. One wondered what they might represent — perhaps stylized hair, or snakes.

From the top of the figure and across its forehead ran a channel. It ended in a small incised cross with a circle carved in its center. It looked to be a metaphor for the real space in which the stone stood. Its true meaning was lost to me but its universal sense of *axis mundi* was profoundly moving. It was here that I experienced for the first time how a work of art can look at you and radiate beyond its power of weight and size.

The sensation of having traveled toward the interior of the earth was overwhelming at the time. Today I realize that I had traveled back in time to the source of art when it was a link between humankind and the divine, and when it reverberated on the deepest and even irrational levels of the human being. In me it touched a magical, spiritual chord in relation to the earth and human existence. Even the trip to the sanctuary had in a strange way become part of the space of the sculpture. I also realized that the space around the sculpture itself had been of essential importance to what I felt, and had created an unbroken unity with the stone.

It is difficult to experience works of art so deeply in today's world, or to encounter works of contemporary art that are so charged with meaning and mystery. When the siting of a sculpture does not take into consideration the space around it, the work can easily be reduced to simply an object. This will make it difficult for the viewer to communicate on a deep level. Where a unity exists between sculpture and space, an impact is created that enables a viewer to enter the space of the art. I think of the lonely figures by Giacometti, sculptures by Moore in the lowlands of Scotland, an early Noguchi in the Kröller-

STONE OF ORIGIN
Lika Mutal
1999
Black granite (front)
Photo: Javier Silva

26

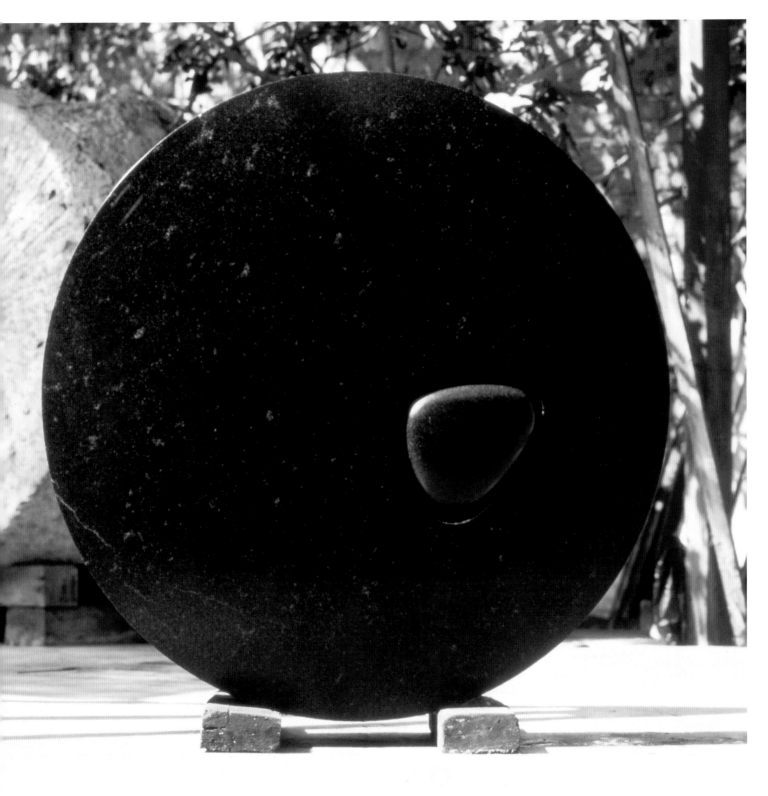

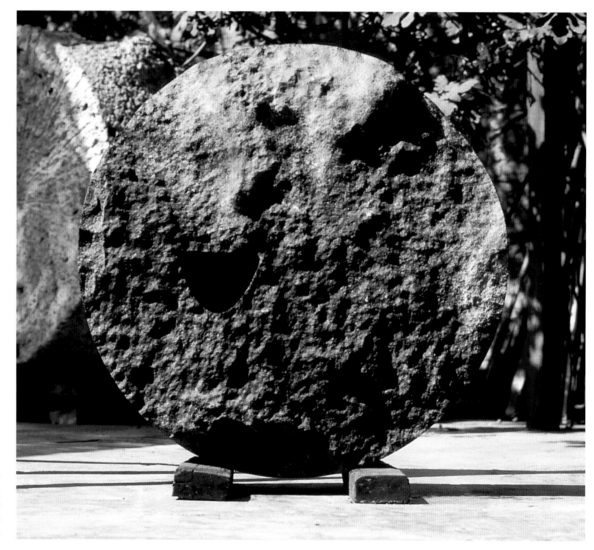

STONE OF ORIGIN
Lika Mutal
1999
Black granite, (back)
Photo: Javier Silva

Müller Museum or of the dynamic and unusual situation in Faret Tachikawa where art is part of the street scene.

A memorable experience I had with a contemporary work of art was when I saw a group of works by Magdalena Abakanowics in a New York exhibition. She is a Polish artist whose work has social and political connotations and is expressed in strong and gripping images.

In the non-sophisticated, simple space of the PS 1 museum, I saw a number of wooden objects that evoked the quality of living beings. They were a group of sculptures to which the artist had given the title "War Games," a fact I did not know when I saw them. The sculptor had taken a group of dead trees to her studio and stripped them of their bark. She had partly dressed them in burlap. In some places they ended in forked limbs. Those she had dressed with metal sleeves and circled the trunks with metal rings. Some of them were as tall as 25 ft. (8.3 m.) and others were bulky. All were monumental. The sculptor had positioned them horizontally on rusted barrels or on low, open steel structures. The position and the whole treatment suggested fallen beings, perhaps dead warriors on improvised biers, though their strongest expression to me was that of victimized trees. At the same time, because of the light and smooth skin of the sculptures, they seemed transcendent and had an otherworldly aloofness.

They did express a haunting combination of the human capacity for cruelty and destruction and at the same time they looked to be victims. They evoked the tragic state of our planet. There were no words or rhetoric, but a simple straight-to-the-heart image. At the same time it was beautiful in its innocence and naked exposure.

Most of us go through life with our senses coated with some sort of protection, and rightly so since we are bombarded with disastrous

information about the state of the world. We are exposed to highly sensational stories designed to attract our attention and stimulate our adrenaline, to which we have become addicted. All this is interlaced with propaganda. Artists participate in the process in order to attract attention and be shocking. To encounter art that does not try to impress by being scandalous can be healing. Maybe this is especially true when the theme is tragic, for then the work of art is a catharsis for the frustration and sense of impotence in a world where the basic quality of life is been threatened.

As for my teachers, I must say that stone taught me all the dimensions of space that are so important in the encounter with sculpture. Stone also taught me the silence that made me aware of my existence beyond the temporal and into spirituality. The person to introduce me to stone was Don Juan, who is now 90 years old and has all his life been a traditional Peruvian stone carver. Don Juan used to speak about stones as if they were living beings, some beloved or extremely reliable cousins, although there were exceptions in the family that I better never work with! The noblest of this stone tribe were the granites, and they were real challenges that needed to be approached in very skilled ways. Don Juan's way of speaking both amused and inspired me, but taught me to face and use stone with a great respect, always leaving features of the original stone in my work. I realized, though, that his way of speaking had its origin in the Andean culture and that he wasn't really consciously aware of the implications that were so refreshing to my European mentality. In 1984, Don Juan took me to a natural quarry in the mountains. There I started a new relationship with stone. Staying for long hours between the hundreds of small black granite boulders gave me a strange sensation of being watched. I felt that there was energy in those stones that communicated with me — some

more than others. Eventually, after many trips to the quarry, the experience turned into an awareness of stone as an emissary of Nature, a world beyond the boundaries of our human world. If I had imposed my ideas on the stones with hammer and chisel, now it was her turn — not to impose but to teach me. I had to be silent and try to understand.

I opted for taking some of the natural stones to my studio and wait for a sign as to how I should open them in a way that would highlight their inner realities. They became landscapes, voyages, places to dwell upon, small gardens of meditation. The specific way to work on this involved silent dialogue in which I was only a willing beginner. So I had to become patient. In the case of one stone I waited for 17 years before the answer came, and water was introduced into my work At times when I would look for a specific idea within the general theme of revealing stone, the stone would close altogether. It still does

this. It is when I don't search, when I let go, that things flow, that something like a revelation takes place. It is then that everything becomes one and that the stone and I meet.

It would be ideal if the observer of art could share the original experience that the artist had when working on a sculpture. But this silence and magic is hard to come by, especially since art theory is so eager to explain what it all means with concepts and theories.

With the onset of modernism, humankind, specially in the Occident, gradually cut its link with the natural world. We became outsiders experimenting with nature, and by doing so we stepped into a void. Nowadays we live that void. So much of the movement around art, even art itself, is the result of it. We try to fill the void with an excess of information, concepts, often with some form of shock therapy.

It is not by coincidence that I recently met

Following pages
Black granite quarry in the north of Peru. It is considered an Apu (sacred mountain) in the process of being born.
Photo: Gam Klutier

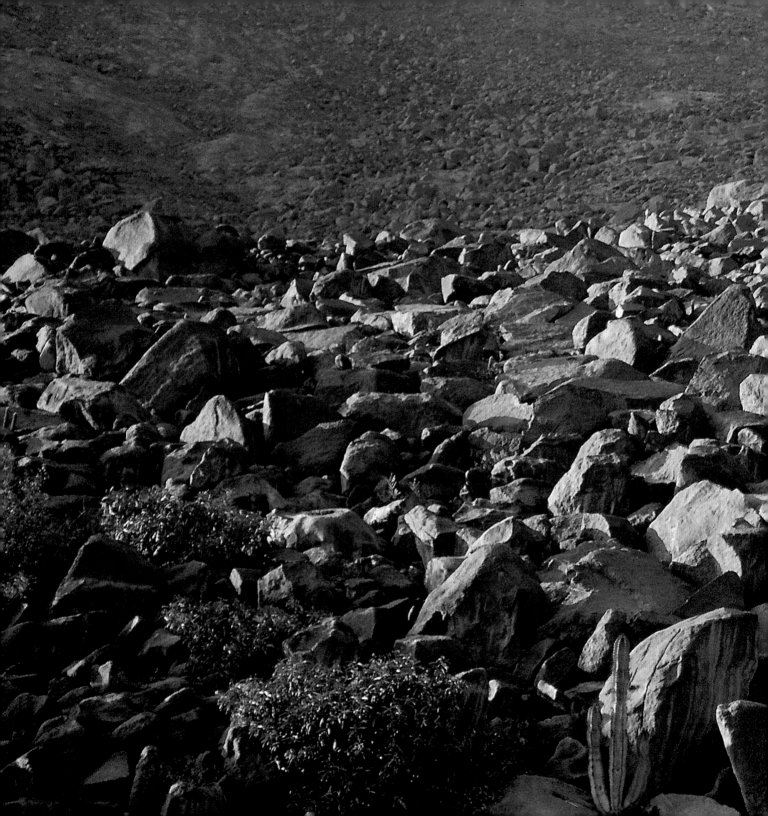

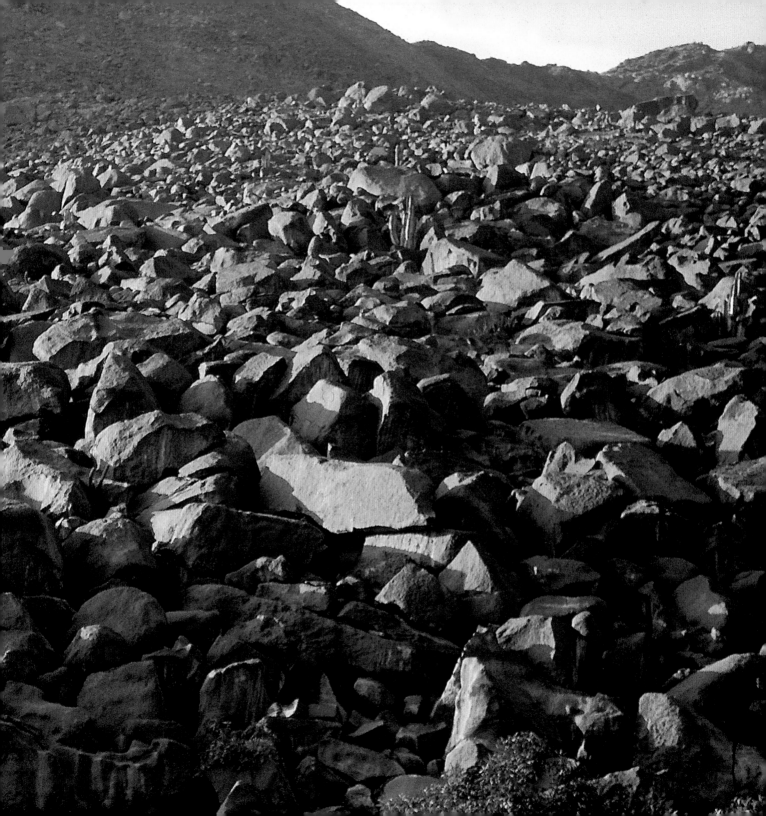

a woman inititiated in the Andean tradition. She is an Apu Collana, a keeper of one of the sacred mountains, the Ausangate near Cuzco.

From her I learned the meaning of the many circles on the sculpture inside the earth in Chavin. In the Andean cosmogony everything is alive and has vision — including stones, rivers, trees and mountains. In the lanzón de Chavin the circles on the stone highlighted this vision.

One could call the Andean world-vision the spirituality of the earth in which human beings, in a position of equality, try to communicate with the secret powers in nature on its own level. Nature has a language that consists of all the natural sounds. So prayers can be in the form of chanting the exact sound of falling water, the sound of lightning when it strikes an object, the sound of the wind when it goes over the water or of a small bird — the piwi — that announces the birth of day. These sounds are chanted for hours on end until a relationship is established with the particular energy of their being.

Knowledge about the energies, properties and power of stone is indeed very sophisticated, confirming why from time immemorial stone was believed to be the seat of spirit. The generous teachings of the Apu Collana enriches enormously my relationship with stone.

This may be the reason why now I carve space in big stones, river stones or ones that I find in the desert. This has become the center of my work. I take these stones in my hands and feel how their energy flows through my arms, giving them wings. Those are the stones with expanding feminine energy. The ones that connect me to the earth are the contracting masculine stones. The stones that fill my hands with tingling that extends into my arms are the ancient ones. The young ones vibrate in my hands and circle my ankles.

It fills me with relief to realize that there is a continuing tradition that respects and

YOU, FROM BEYOND
Lika Mutal
1992
Black granite
Photo: Javier Silva

cherishes nature for itself and its spirituality. The Andean world has been in hiding for 500 years and now it is trying to find a voice with which to communicate its tradition to the outside world.

Our teacher can have the name of a guru or a stone carver or an Apu Collana or can just be stone itself. Through our teachers we can reach deeper or higher levels within ourselves and expand our consciousness.

The more this happens, the more we will be able to sense and grasp the subtler meanings in art.

Art is a both a metaphor and a thing in itself.

The metaphor can be explained. The thing in itself cannot — it is rooted in the mystery of creation. Since time immemorial expressions of this mystery have conveyed a sense of eternal truth. Words cannot describe it. It has to be experienced to be understood. ✿

Encounters with Works of Art

by Thomas M. Messer

We meet and are met by paintings, sculptures and other manifestations of visual creativity much as we meet or are met by people. Encounters vary in depth and significance from the casual and trivial to the significant and moving. The former is an everyday occurrence, the latter is rare. But even among extraordinary experiences the range varies from the stimulating and worthwhile to the determining and unique, from ordinary enrichment to the realization that what we have experienced changes our perception of life and reality.

I prefer not to dwell upon the ultimate and the sublime — upon the effects of a late Titian, e.g., or those of the final years of Rembrandt's painting, the contemplation of archaic Greek sculpture or of impressions left upon me by masterpieces of Gothic and Baroque architecture. Such quintessential works of art exceed my descriptive and expressive capacities and I would rather abstain from comment without thereby denying their impact. Instead I prefer to testify to responses to works in the modern era in which traditional values are challenged by inventive dimensions and in which the concept of beauty is necessarily subject to redefinition.

By way of example, I may offer descriptions of two paintings that moved me deeply, one by the Norwegian painter Edvard Munch, the other by the Russian-born Vasily Kandinsky. Both artists exhibited their paintings in Prague, where I grew up, but did so before my birth in 1920. It was therefore not before the early fifties that I was introduced to Munch's crucial contributions through a retrospective exhibition of his work at the Museum of Modern Art in New York. As for Kandinsky, his then radical advances were best seen at the Museum of Non-objective Painting, the precursor of the Guggenheim Museum where, in a modest townhouse that was later removed to make space for Frank Lloyd Wright's edifice, nonobjective painting with Kandinsky as its primary champion, was on almost permanent view. The specific examples here described are of such importance within the artist's oeuvre that I returned to them many times thereafter.

THE DANCE OF LIFE
Edvard Munch
Oil on canvas, 49½" x 75"
1899–1900
National Gallery, Oslo

The first is *The Dance of Life* by Edvard Munch. On a meadow along the shore at Åsgårdstrand, three stages of Woman dominate a frenetic scene of passionate dancing couples. A virgin in white, smiling and pink cheeked, reaches out to a blossoming flower on the painting's left side. In symbolic contrast on the right, stands an older woman, hands folded, withdrawn, saddened expression and somberly attired. Both are turned toward the center, which is occupied by a dancing pair — a man in a dark suit and a seductive woman in scarlet dress, whose hair and skirt reach out engulfing her partner. The two are sunk within each other and move obliviously without will or purpose. A distant sun or moon penetrates the waters with its ample reflection.

In this tripartite conception of Woman, explicit meanings are reinforced through symbolic imagery and color. Subject matter, formal structure and symbolism bespeak in

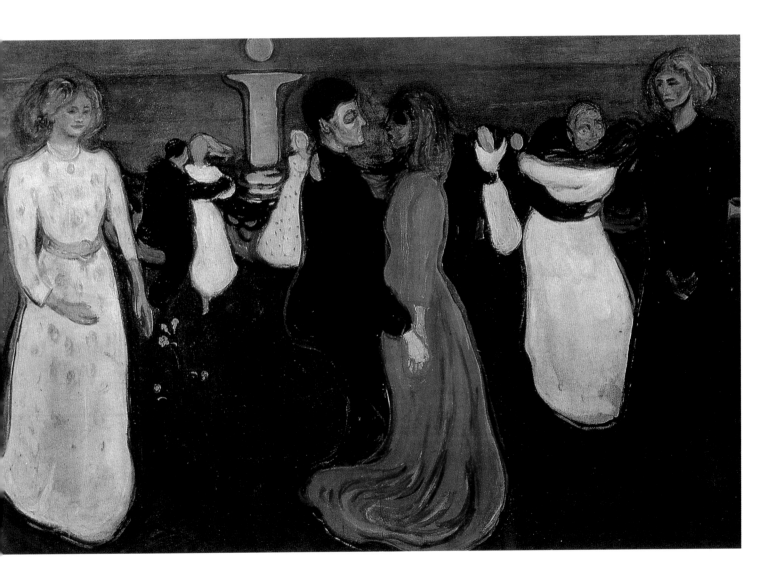

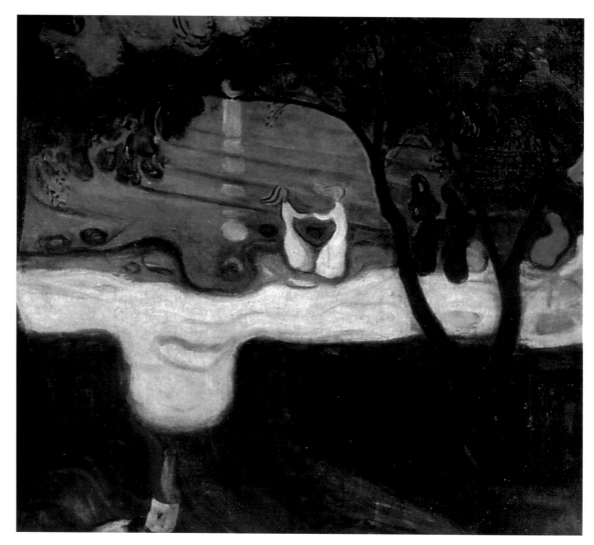

THE DANCE ON THE SHORE
Edvard Munch
Oil on canvas, 1900-2
Photo: John Boulton Smith

unison the passage from innocent girlhood to rapturous oblivion and the disillusionments of old age. Munch's paroxysms take him beyond the limits of rationality, giving to this and other paintings a hallucinatory quality. In what may be the artist's finest work, the particular is transcended in a quest for the universal.

The Dance of Life may be seen as the centerpiece in the great thematic cycle that in Munch's imaginary world comprises the human condition the artist referred to as *The Frieze of Life*. Freely adjoining one another and without an explicit narrative order, these canvases and the related graphic sequences converge on the fateful love embrace of the central couple, to move simultaneously toward youth and innocence, age and dejection and beyond the "Dance," toward birth and death, lust and fertility, and toward melancholy, jealousy and such inner portrayals as Munch had completed by the turn of the century. *The Frieze of Life* thus becomes an anthology of the psychic state of modern man.

It is difficult to say, indeed difficult to know, why *The Dance of Life* should have specific meaning to any particular viewer. Along purely formal lines, it is possible, of course to cite the impressive dimensions of the canvas, its deliberate subdivisions within a flowing unity and its dramatic contrasts of dark and light areas. Beyond this, one may be moved by the work's allegorical content, the poignant juxtaposition of the ages of Man and Woman as expressed through color symbolically deployed. And finally, by the suggestion of man's merely temporal existence in the presence of eternal nature. However, none of these features are compelling in themselves. If we do respond, it is so because sentiments and emotions we ourselves experienced have assumed universal validity through the artist's forms and images.

The next is *Several Circles* by Vasily

Kandinsky. Scores of small, round shapes, some contained within others, some overlapping, orbit about, or sometimes within, a dominant blue circle surrounded by a shining aura. These multicolored constellations float on a modulated black surface, which, through the nuances of its texture, suggests greater or lesser depth, as in water seen from some height. *Several Circles* is, in part, pure geometry and as such engages our rational faculties. But the painting is also pure magic, possessed of mysterious, revelatory powers. For circles, and by extension celestial bodies, orbiting through the universe, speak to our emotions, reminding us that insignificant humanity participates in a cosmic order. Kandinsky's contacts with theosophy and anthroposophy as well as his lively interest in astrology are well documented and *Several Circles,* while not limited to such interpretations, certainly has the capacity of touching a chord of the sounding cosmos.

SEVERAL CIRCLES
Vasily Kandinsky
Oil on canvas, 55¼" x 55⅛"
1926, Solomon R.
Guggenheim Museum,
New York

The painting is among the most perfect of Kandinsky's creations. It was completed not long after the German experimental Bauhaus school, with Kandinsky on its faculty, moved from Weimar to Dessau. The circle by that time had assumed a place of importance in the artist's pictorial vocabulary. It had become the sole motif in several works between 1923 and 1929 and the example here presented, together with a painted preparatory sketch one half its size, is the first oil painting exclusively devoted to that image. The artist himself had inspiring things to say about the circle. According to him, the circular form in itself was not the object of his fascination, but rather its evocative powers through which hidden meanings were revealed.

Several Circles may speak to us on more than one level. Superficially, we respond to something purely optical that evokes a sense of the harmonious, comparable to the delight conveyed by musical sounds. But this is not

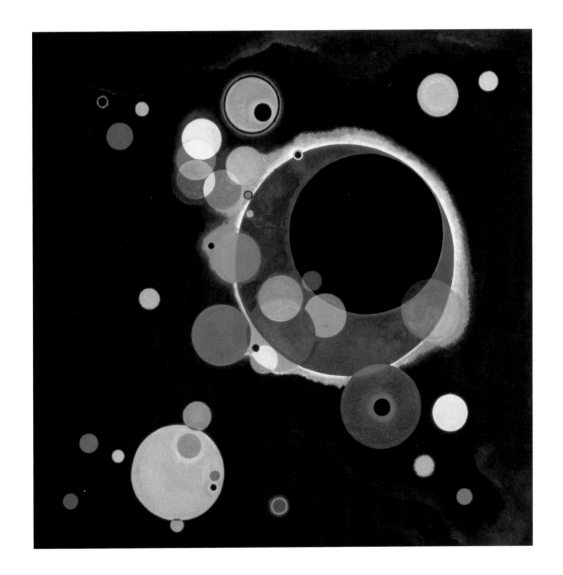

all, for again, as in music, visual harmonies are not only based on gratification of the senses but derive from a projection of an essentially wordless order that constitutes the true content of significant works of art. Kandinsky does not claim explicit meanings for his abstract, nonobjective painting. He allows us to seek associations with universal verities, whether conveyable in words or not.

Sensitivity to forms and images is of course an essential precondition to contact with works of art. Like other human faculties, it may be innate, cultivated or both. It is the function of art education to further existing aspiration for a deeper understanding, primarily through contact with original works of art.

The less insistent, the less pedantic, the less dogmatic a form such an introduction takes, the more likely is it to bear fruit. Silent exposure is of the essence. The realization that a work of art must be experienced, i.e., looked at long and repeatedly and absorbed by one's senses is obvious to those who have experienced the process.

The essence of art eludes a merely rational approach. A grasp of visual content remains an intuitive exercise and art, in a sense, therefore, cannot be explained. Information about art has its value, of course, but not when it substitutes itself for the primary visual immersion. Similarly, the printed page with its verbal messages and reproductions through mechanical processes is useful only as a source of information, preceding or following exposure to the original work. Color reproductions in particular tend to undermine authentic experience since they displace an admittedly indistinct memory with distinct but inevitably false visual statements, thereby obliterating much that is of value. Art history too has its own premises and must be related to the viewing of individual works with care, since it emphasizes contextual rather than sensuous knowledge. As Barney Newman

used to say: "Art history is for the artist, like ornithology — for the birds!..."

One of the best ways through which to achieve visual involvement is through the installation of original works of art. The silent process of hanging and placement, depending largely upon the exercise of visual acuity, may establish a high degree of proximity between an art object and a particular pair of eyes. Art making, too, even if practiced by avocation only, has much bearing upon comprehension, just as instrumental training is of inestimable value for the comprehension of music. But then this, too, is useful only where certain preconditions exist.

In summary, not all of us can be on first-name terms with the Muses, but those who can should be rewarded by messages issuing from original works and not be deflected by an excess of theory, verbal translation and other indirections.

The question of who and what taught me is very personal and no single response can claim general validity. For me, music came first and, as a result, I initially learned to appreciate the visual arts by way of analogy. Music came to me through my mother, who led me to respond to sounds and rhythms while I was learning how to speak and walk. She arranged piano lessons for me, early, and daily practice without professional ambitions or pretensions, remained with me through many decades of my life. Music as practiced and as consumed, probably was for me the most effective educational tool. The visual arts came half a decade later, still well before my 10th birthday and it came through my father, himself an art historian. From the beginning it concentrated upon the original experience, through museum visits and occasional contact with artists. By way of preparation for visits to European public collections, there were slide projections in black-and-white of the classics, during which the informational value was emphasized. The habit of museum and gallery

visits having been formed in my childhood, continued thereafter and acquaintance with formerly inaccessible collections such as the Louvre and the Prado became a program before I engaged in formal studies. I did not have school teachers, therefore, until I entered graduate school at Harvard University. Among them Jakob Rosenberg in his course on the Dutch 17th century continued to emphasize the fundamental importance of exposure to originals as well as the concept of quality through the process of formal analysis. I benefited greatly from such a discipline and from descriptive assignments at Harvard's Fogg Art Museum and at Boston's Museum of Fine Arts — a preparation which served me well once private and studious pursuits gave way to functioning in a professional capacity in the modern museum field. At that stage, artist contacts and studio visits assumed an important place in my efforts to comprehend the changing nature of art forms and their implication for the lives of individuals and of society.

Cezanne's marvelous statement to the effect that art is an expression parallel to life suggests that we learn about art through life while retaining the separateness of the two worlds. Art thus becomes meaningful to the extent to which it reflects and sharpens life experience — love, anguish, order, freedom and much else. In the end, our teachers are merely intermediaries, people with the ability to convey and transmit to us authentic experience. ✺

About the Art of Looking

by Gabriele Czöppan

To look at art for me means the art of looking, seeing and understanding. The way I look at something influences my entire life. Art enlightens the way I look and experience everything. When I see something—a painting, something in nature, a person's face or just watch a television show—whatever I look at I have to realize that there are a multiplicity of meanings and reactions present in the way I can interpret it. Nothing is what it seems to be.

The image of a snake, for example, may provoke fear and disgust or it can be seen as the most beautiful symbol of passion, and beyond the metaphorical it can really open your mind. In psychology it is called the unconscious and it can lead you to your inner self.

To look at art helps me to understand the images and symbols of the universe. It not only stimulates me to become an explorer of the world but also, as an art editor, to pick out all the depths and profundity and different parts of an image or a feeling.

I can recall special moments from my childhood when works of art captured me and I began to understand the uniqueness of the emotional quality in art. One of the most startling experiences occurred to me when I was a teenager. My grandmother acquainted me with art, its images and its history by

showing me not only art books on German expressionists and French impressionists but also by explaining to me the techniques used by my grandfather, who happened to be an amateur painter.

My favorite picture at that time was a reproduction print of Georges Seurat's *Sunday Afternoon at the Grand Jatte* that reminded me of our family excursions to the countryside near Munich on the river Isar. And although the whole atmosphere within the picture seemed to me rather cool, I could feel and see the heat of a summer's day when people are escaping from the sun and are lying lazy in the shadows under a tree.

I had neither known the painter's mathematical composition system nor his belief in building harmony on colors. I had not noticed that the postimpressionist Georges Seurat, who died at the age of only 35, had left no more than five major paintings that revolutionized art more than a hundred years ago,

A SUNDAY AFTERNOON
ON THE ISLAND OF
LA GRAND JATTE
Georges Seurat
Oil on canvas, 1884–1885
The Art Institute of Chicago

when photography evolved our perception. Yet, at my first sight only of a reproduction of Seurat's painting, I was totally stunned.

It struck me to the bottom of my heart when I encountered the original at the Art Institute of Chicago for the first time in my life, about eight years ago. I was deeply affected and I would have liked my beloved grandmother (she is still alive) to share with me my feelings as I stood before the great painting.

I never imagined its greatness or its size—which enlarges the painted figures into real persons—and its profound and subtle expression. There are thousands of tiny little brushstrokes and dots spread all over the canvas that form an entirety of harmony, peace and quietness. Every single color spot fits into the composition and blends to only one impression: It seems to me as if atoms of the universe have been put together into one atmospheric image.

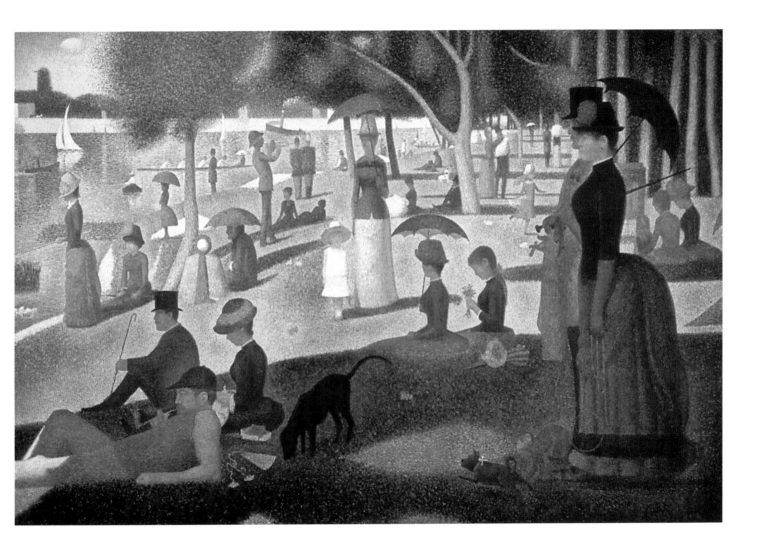

Observed from a certain distance I cannot make out one single dot but I am wooed softly by a symphony of colors, shapes and shadows. Systematically divided tones on canvas merge through my eyes to a harmonic orchestra. There was strength amid calmness in the painting and I imagined hearing the music of Mozart and Bach.

At second sight, I became conscious of what seemed to me the essence of the painting. The grass consists of thousands of green, violet, ocher and yellow single dots, with the shadows painted in the same but darker-toned brushstrokes. The figures are reduced to silhouettes standing still on a stage. Only a few faces are shown and there is only one person who is looking directly toward the viewer: a little girl whose white dress is seen as the brightest spot in the center of the composition embodying light itself.

Although Seurat's technique and theory was widely analyzed, I was more attracted to his fundamental message of harmony and contemplation than to any art historical conclusion. There is a tension between strength and emotion, a mystical connection between realism and sensibility that moves me deeply.

Some months later I came face to face with the Seurat once again in Munich. Upon seeing one of Thomas Struth's "Museum Photographs" in a private collection I suddenly found myself completely and unexpectedly transferred again to the Art Institute of Chicago. I was shocked and moved by his photograph.

People whom I had never seen before stood there in front of Seurat's *Sunday Afternoon at the Grand Jatte* and viewed the painting with the same intensity I had experienced in Chicago. After a while my attention switched over to the viewers in the photograph. Their expressions seemed to ceremonially surround the painting yet I only saw their backs. The stillness reigning within the painting had quieted the viewers

themselves as soon as they set eyes on it. Only one young couple on the right border of the photograph infringed upon the solemn rite of art viewing, reminding me that I wasn't looking at the original Seurat but only a photograph of museum visitors viewing this painting.

At first sight these people were standing there at exactly my eye level, almost life-size, and blocking my view to the rare painting. Yet still they fascinated me. Grouped in chance poses around the painting they themselves formed an artistic composition. The various blue tones of their everyday clothing were splendidly analogous to the dabs of ocher on the canvas. Their outlines were slightly indistinct; they seemed caught in motion. In contrast, the walkers sauntering casually along the banks of the Seine or sprawling on the grass that Seurat had captured on canvas were as sharply recognizable as if they had been etched there.

As in the Seurat painting, light plays a decisive note here too, even though the artist isn't creating staged theatrical images. Struth, who was trained strictly to avoid showing emotions in his photographs by the German art professors Bernd and Hilla Becher at the Academy of Fine Art in Düsseldorf, gets deeply involved in a passion, love and admiration for art. So was I. He banned the aura of an older work of art and I was captured by his new work of art. I became aware of its mystery and spirituality and realized that one can hardly explain art. One has to get involved in it.

I felt strangely connected to these museum visitors. They seemed to be driven by the same purpose that I was: the deeper understanding of art.

These people may have only lingered one fleeting instant in front of the painting and the camera caught this one, intense moment. The room in the photograph and the painting inhabiting this room conveyed the impression of timelessness — the kind that also impresses

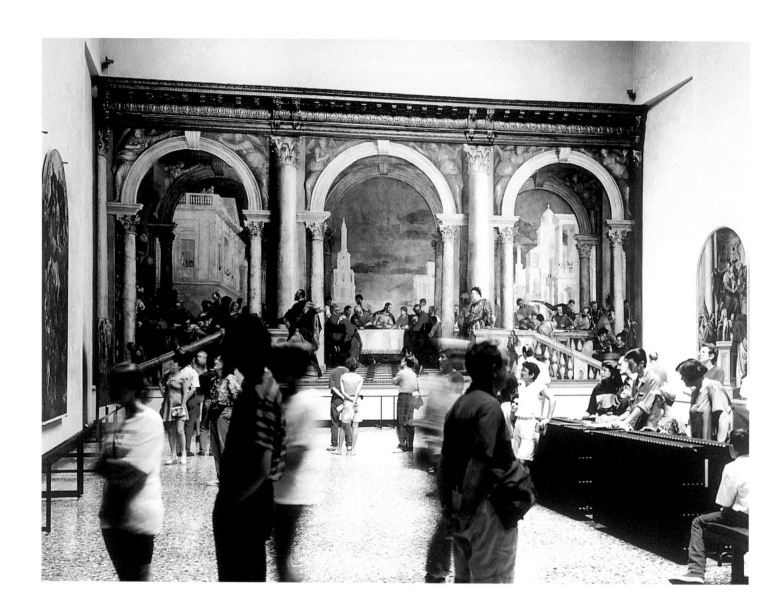

ACCADEMIA, VENICE
Photo: Thomas Struth
From his series,
"Museum Photographs"

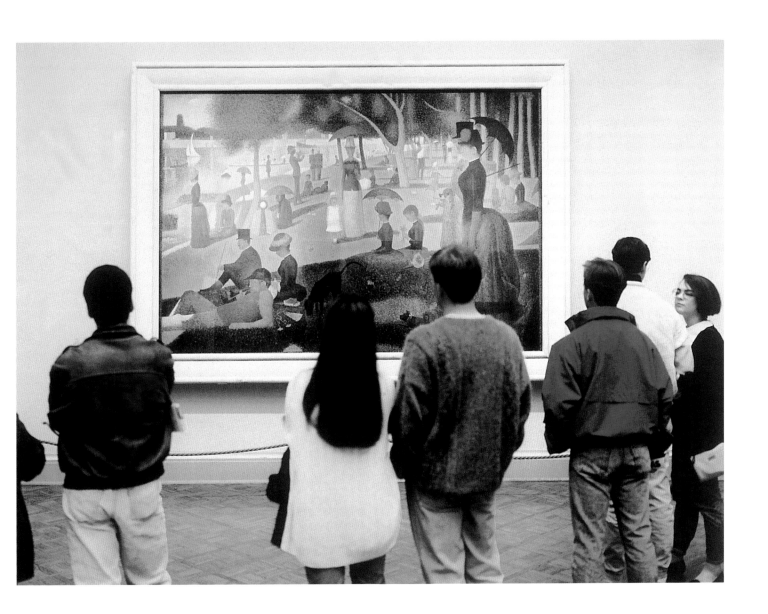

ART INSTITUTE OF CHICAGO I
Photo: Thomas Struth
From his series,
"Museum Photographs"

itself on us when we wander through a museum. It remained untouched by the present.

Suddenly the painted work of art seemed strangely removed and unreal while the visitors in the photograph seemed to be all that was real. It wasn't the picture within the picture that became the center of my interest but the observers of this picture. I asked myself, What are they doing there while they look at the Seurat? Are they looking for some specific piece of information? Are they absorbed in the painting or only giving it a quick glance? Are they wondering about the people who are turned in profile to them? Are they looking out from their own picture or in the direction of their observers, or rather in a direction that we can't see into because our field of vision is limited by the frame of the photograph?

In fact, this last point irritated me and remained in my mind for quite a while. Later when visiting museums myself I often caught myself watching people out of the corner of my eye trying to study their way of seeing. Several of them seemed to forget their surroundings as they stood silent and occasionally smiling before a masterpiece; while others rambled steadily on as though recording data by taking snapshots without really having looked at the paintings.

Nevertheless they all were attracted to the artwork somehow, though many of them did not express their feelings about it. Thomas Struth caught that special moment when an artwork expresses itself to its viewers. His 17 "Museum Photographs," published in a book by Schirmer/Mosel publications (Munich), taught me a lot about looking at any art. And so did another artist.

I had one of my most spellbinding experiences with art three years ago when I visited an exhibition in New York. Held at the Holly Solomon Gallery, it was called "Sleepwalking" in homage to Bellini's opera "La Sonnambula," and to all synthetic experiences sufficiently

lavish to suppress conscious thought. And like a sleepwalker I was touched by it. I almost forgot myself by stepping into a walk-in picture by the New York artist Rob Wynne. The walls were covered in hand silk-screened wallpaper, full of butterflies and eyes. Hung on top of the wallpaper archival photographs in felt frames circled around the theme of the missing opera.

In the tradition of the surrealists, Wynne unfolded a series of word games and picture riddles: the frames were embroidered with words and pieces of sentences that seemed unconnected to the picture within the frame. Intertwined with emotion and meaning, Rob Wynne's work offered me a trip through my own dreams.

A picture of 11 bones was contraposed by the lines of an opera's aria: "The stage remains empty for a few seconds," while the four women's names Lucia, Norma, Medea and Violetta, which represent the most famous opera roles of Maria Callas, were resplendent around the picture of a volcano. The raging eruptions of lava and tragedy arise in my imagination only through their absence.

In another picture a phrase taken from a caption for a vanished work by Duchamp: "Private Collection, location unknown, original lost, dimensions unknown," surrounded an image of buildings destroyed by an earthquake. I could feel the emptiness left by a vanished work of art contraposed with the chaos of a natural catastrophe.

And at last, a photograph of Maria Callas as Amina, the heroine of "La Sonnambula," is framed by the sentence "I never thought I would die so soon," that was also Bellini's epigraph. The impact of these words on the picture was immediate and irrevocable.

Although there was no music to hear, everything was staged like in opera where emotions are exaggerated to drama and life is near to death. I could hardly hear anything

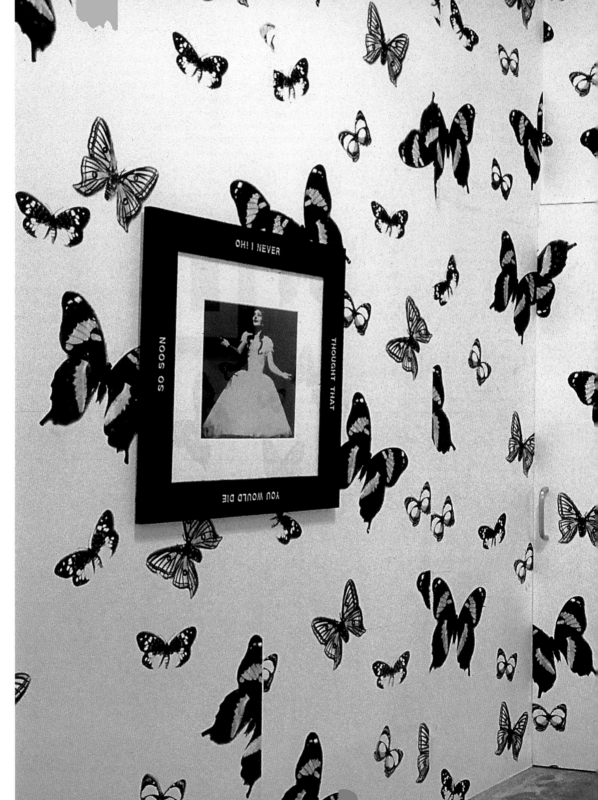

ROOM
Rob Wynne
from "Sleepwalking" exhibition
Holly Solomon Gallery, New York
April 6 – May 4, 1996

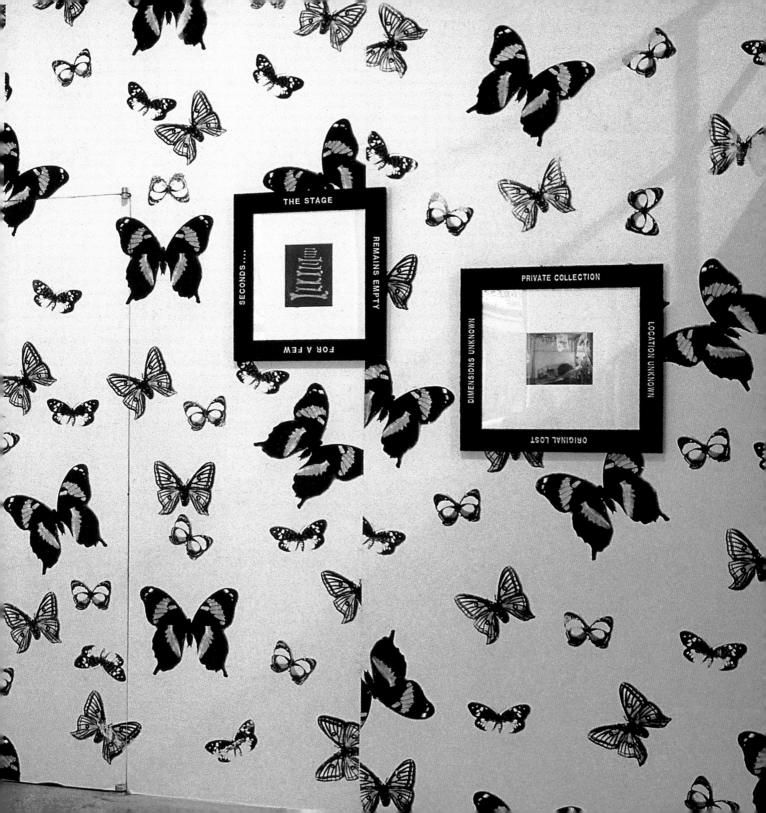

but imagined arias and music in the room. The action only took place in my fantasy. I felt like a fly on the wall watching the performance. Absolutely sympathized, I started to be drawn into it.

As the Romantics once did, Rob Wynne dreams of a *Gesamtkunstwerk*—a total work of art—which is made up of elements of visual art, literature, music and theater, and which considers all aspects of the human spirit. Every individual element is placed in relationship with another one while referring to yet a third one in a larger context; each and every part exists within a network. In the works of Rob Wynne this unity was laid bare before my eyes.

Rob Wynne plays upon the viewer's habit of constructing a narrative out of the juxtaposition of images even where language is silent.

Thus I realized from the beginning that words are a reduction of the image, an attempt to capture through language the essence of something that will inevitably elude that attempt.

To name my most important influences, I have to say that artists really opened my eyes. The ones I met during the last decade helped me to look at things in a different way. The ones whose works of art came to me through my profession challenged me to master it.

To characterize only one, the German artist Thomas Struth drove me to my own "places of the unconscious" as he has titled his black-and-white photographs of deserted streets. Although there is nobody visible in these pictures their places are still populated in my memory. As it was put a long time ago, "an image is the presence of the absence." And my eye is unconsciously involved with this *Kunststück* (ability). By looking at Thomas Struth's photographs I became aware that human perception is a highly complicated process. Seeing means first of all selecting

and only I perceive what I observe or what I believe in.

But there were also some persons I would like to call teachers who led me to a true revelation. The British author John Berger, who taught me mostly about my "ways of seeing," shaped my perception a lot with his book of the same title.[1]

Berger began work as a painter and a drawing teacher but soon turned to writing. I once met the English artist, who is now 72 years old and living in a peasant farming community in the French Jura, at an exhibition of his own drawings and pictures in a small gallery in the countryside of southern Germany.

On a chilly November evening, Berger was lecturing in a baroque Bavarian chapel. While listening to his essay about Giacometti, cold air crawled up my legs, but Berger's words about a man who believed in his act of seeing as an act of praying warmed my heart.

"Seeing comes before words. The child looks and recognizes before it can speak," he says. Berger unfolds his beliefs by claiming for the image a prior and more central place in the human sensorium: "It is seeing which establishes our place in the surrounding world; we explain that world with words, but words can never undo the fact that we are surrounded by it."

Memories of overwhelming experiences of art come into my mind when mere words cannot describe my impressions of Raphael's and Michelangelo's frescoes in the Vatican or St. Peter's in Rome.

Based on a famous BBC television series of the same title, John Berger's book explores the historical development of oil painting and publicity and the ways our perceptions of bodies of art are mystified.

From my personal view, this book and his following "About Looking"[2] have also served as a welcome companion on the road to my self-exploration and the search for wisdom.

Berger shows me how the framing of visual images shapes my perception of those images and of what they attempt to represent.

In the act of viewing I situate myself in the image I view, thus taking on a special perspective relationship to the things viewed. "Perspective [which is not a natural but a cultural phenomenon] makes the single eye the center of the visible world. Everything converges on to the eye as to the vanishing point of infinity," Berger writes.

It is not to say that we should attempt to overcome our particular ways of seeing. That cannot be done. It is instead a call to be aware of the many ways of seeing those images we have become accustomed to, and what we reproduce in our own lives. 🌀

[1] John Berger, "Ways of Seeing," Penguin Books Ltd., London 1972

[2] John Berger, "About Looking," Writers and Readers Publishing, London, 1980

The Heart Shall Be Weary and Wonder

by Ronne Hartfield

"... and the heart shall be weary and wonder, and cry like the sea."

These words of Arthur Symons are quoted by the great African-American sociologist, W.E.B. DuBois, in his classic work, *The Souls of Black Folk.* They are evoked as testament to the human encounter with deep interior meaning, and for me, they are words rich with the vast possibility of everyday people to be touched—and strengthened—by something larger than the ordinary life we live. In this paper, I want to talk about that place of encounter as it can occur when we see—not simply look at, but see—a great work of art.

Numbers of prominent scholars of art confirm that there is some real and profound connection that can be established between an art object and a viewer, something inchoate, beyond speech, that can and frequently does occur in the intimate human encounter with a work of art. This "something," whether characterized as a "peak moment," a "liminal experience" or an "engagement of the spirit," is a lived reality shared by so many people from so many different times and places that we have to acknowledge the truth of the "something," even as we disagree on the terms of its nomenclature. For the purpose of this paper, I want to affirm the potential of visual art

as a mode of sacred illumination, of opening the inner eye, of touching and being touched by real although barely apprehensible power.

The power of art lies in part in its amazing ability to cross boundaries of space and time, of race and gender, of cultural histories and faith structures. A Tibetan Buddha can bring a 20th-century North American Christian to her knees. In the great art museum in Chicago where I have worked this last decade of the century, the first-floor galleries exhibit sacred images from China, Japan, Korea, India and Nepal, alongside temple fragments from ancient Greece and Rome, sacred masks from West and Central Africa, carved Aztec and Mayan deities, and an entire altar from 16th-century Spain. Most mornings, I park my car at the museum's rear entrance on the shores of Lake Michigan, and walk through these awesome corridors, turning toward my office through galleries filled with quiet. By the time I reach my light-filled office upstairs, I feel

that I have been blessed in a dozen languages, by as many faces of God as have been drawn or carved or painted by people I will never see. Through their beautiful works of art, I have shared their own sacred encounters; they have allowed me to connect.

Connection is a word people understand in different ways. In today's technologically high-speed world, to connect can mean I send you an e-mail in Kyoto and can read your reply in less than five minutes. We can connect with a flick of a finger, without even noting each other's name or address, because that information is already in the computer's memory. These innovations are marvelously efficient, even amazing, modes of connection, and I am grateful for them because without them some of us might not have been able to be here today, participating in this important symposium.

All of that notwithstanding, however, is it not equally amazing that in less than two

minutes we can be struck dumb, stopped still in the midst of all of our high-speed freneticism, our endless meetings, our ceaseless speaking and planning and our busy thinking by turning a corner and seeing a great work of art? Such images can, in an instant, cross all manner of boundaries to connect with me at the deepest layer of my vital being, layers I wouldn't even know existed if these works had not the power to pierce the barriers of matter and connect one single soul to another, to put me in touch not only with the artist, and with a not easily accessible part of my own being, but with something I call the sacred.

Let me begin by sharing with you two perhaps unlikely images. One of these is the *Venus de Milo*. There is a story told about Noël Coward who, when visiting Paris, sent a picture postcard of the *Venus de Milo* to his little niece. What he wrote on the back of the card was *"If you don't stop biting your nails, this is what will happen to you."*

We laugh at this story because we've all seen enough photos of the *Venus de Milo* to know that she has not only no fingernails, but no arms. Think about that. The *Venus de Milo*, one of our most important cultural expressions of the beauty and harmony of the human form — most specifically the female form — has no arms! How can this be? Perhaps it is because the visible part of the *Venus de Milo* is so perfect that we unconsciously imagine her arms. Or perhaps the eye ignores the facticity of her armlessness, focusing instead on the classical perfection of the rest of her. Certainly, people never did talk very much about her having no arms. In actual fact, when the Venus was found in a cave by a fisherman on the island of Milos in the early part of the 19th-century, her arms were there, though broken. They disappeared somewhere between that Greek island and the Louvre, where she was finally installed, and where many of us continue to contemplate her armless beauty today.

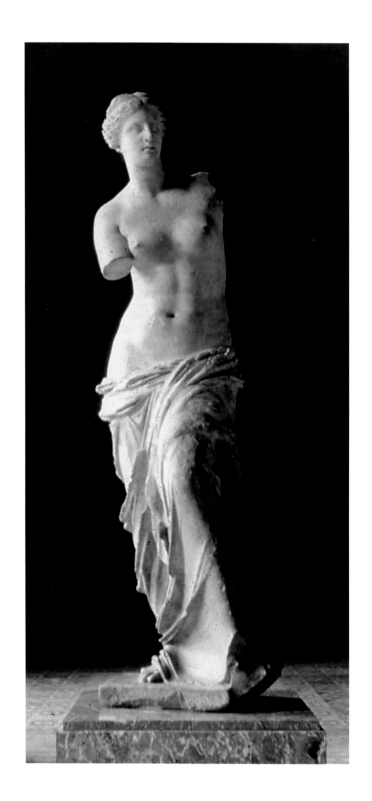

Now what does the *Venus de Milo* have to do with my sense of the sacred? Well, let me compare her with another and very different image of the human form, and perhaps in the comparison the reasons why I give will emerge. Let me ask you to reflect upon another armless woman, this one carved in plaster about 50 years or so after the *Venus de Milo* made her way to Paris.

This other armless woman is in Paris, too. She is the work of the great French sculptor, Rodin. She does not display the smooth restrained perfection of the *Venus de Milo*, who lost her arms so late in her life. Rather in the Rodin sculpture, armlessness is a part of the intentionality. She was created by Rodin without arms—he does not implicitly ask us to imagine her with arms or to ignore the lack of them. Rather, the very title of the work conveys to us how we should approach her as she bends and twists upon herself, in a posture somewhere between anguish and prayer.

Rodin entitles the work *La Meditation sans Bras (Meditation Without Arms)*. We are called explicitly to meditate on the profound complexity of her—not pure or serene like *Venus de Milo,* this armless woman is vulnerable, helpless, radically dependent, while at the same time undeniably an image of empowerment, and strength, even splendor. It is this duality that Rodin calls on us to contemplate, and it is this duality that propels me to understand my place in the cosmos.

I am called upon, as part of a splendid and yet broken creation, to make oblation to that. As Rodin makes clear, our relationship to God is essentially armless—not because our arms were broken off from our bodies late in life, but because our inherent condition is to live as a broken human being in a broken world and to celebrate both that and whatever there is of the wholeness within it. The lesson of Rodin's *Meditation* is that there is splendor and strength in the midst of brokenness—

VENUS DE MILO
Greek, 130–120 B.C.
Parian marble
Musée du Louvre, Paris

that there can be more power and beauty in struggle than in smooth and heroic perfection. I give thanks for that. In my work I am privileged, occasionally, to see teachers on the West Side of Chicago who struggle splendidly, teachers who persistently work at teaching the immense reaches of the globe to a child who will probably never see the Indian Ocean, and who, as amazing as it may seem, may never even see Lake Michigan on the eastern shores of their own city. I think of parents whose lives, without remunerative work, even without hope for work, without education and without even a vision of what education might make possible, continue to send the child off to school with shining braids and polished shoes, reflecting a stubborn pride and lavish care which defies the dimness of their future. I am privileged in my church to share in a community where I sometimes find astonishing moments of connection. This is a community in which the

loving labor of the choir sometimes makes music so lovely as to make me weep with joy; in which I am privileged to have access to the dignity and power of a liturgy that allows me to confront, to know both my armlessness and the deepest sources of my power.

This is a place in which I can occasionally transcend my single armlessness, my separate self and find communion with a larger humanness, and even with something I experience as the sacred.

And I want to close by sharing with you a very important connection I experienced as a young girl, an unusual connection whose lessons have remained with me throughout my life. This connection was with a French painting from 1884, *Song of the Lark* by Jules Breton. It is a picture which occupies a particular, though not rare, place in the hierarchies of museology. It is deemed "good enough" to be held in the permanent archival collections of the Art Institute of Chicago, and it is occasionally

La Meditation sans Bras
Auguste Rodin
Bronze
Inventory number S.792
Musée Rodin, Paris
Photo: Bruno Jarret
©2000 Artists Rights Society
(ARS), New York/ADAGP, Paris

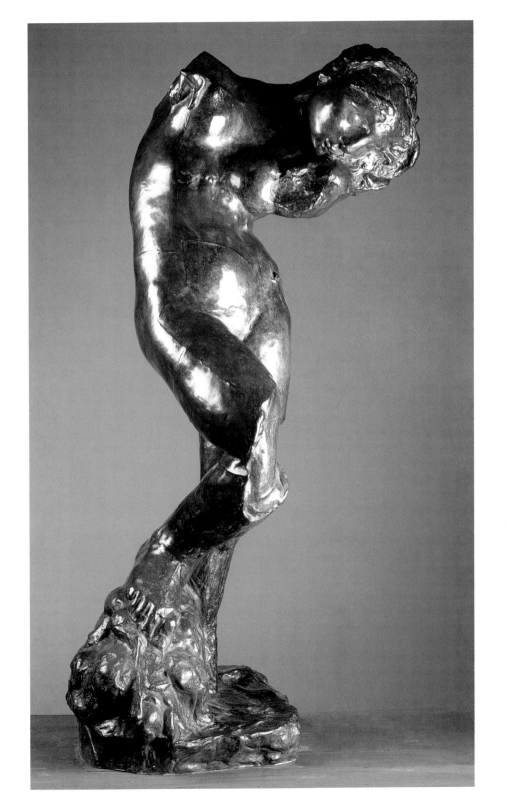

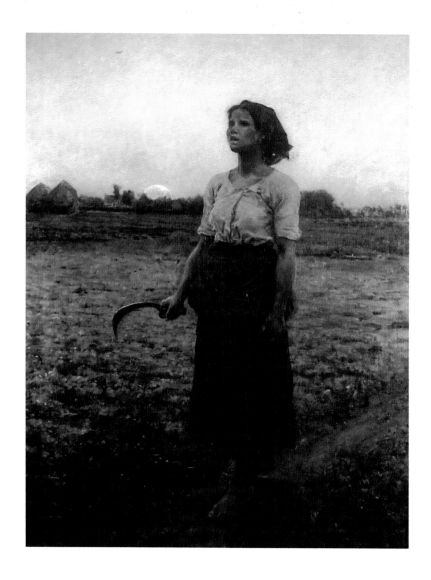

brought up from dusty storage vaults for public view. It is said to have been one of the favorite works of art of Eleanor Roosevelt, a very special woman who was the wife of the president of the U.S. She saw this painting and was very moved by it on a visit to the Art Institute during World War II. However, this painting is generally consigned to that murky category of works not agreed upon by many curators as not really "important" works.

In the interest of time, we will not today analyze the reasons for these designations. Rather, I mention the difference in the aesthetic judgment of curators and that of Eleanor Roosevelt in order to mark the particularity of any individual's response to works of art. The wife of our renowned president was taken with this image, stopped in her hurried tour through the museum, not because of an art critic's seal of approval, but because something captured her eye, her mind, her spirit. I have read a great deal about Eleanor Roosevelt, and I like to think that what reached across to Mrs. Roosevelt was, at least, in part the same quality that connected me to that same painting when I first saw it as a nine-year-old girl. This artist, Jules Breton, captured a quality of profound longing, of deep incalculable yearning for something larger than the everyday life we live. The peasant girl in this painting worked much harder than I ever did in my carefree urban childhood and certainly had a far different life from that of the extraordinarily privileged wealthy woman who was a niece of one president and wife to another.

So what was the binding consonance, the connection, with this painting that Eleanor Roosevelt and I both loved? My fascination with this picture began when I was only nine years old, but became legendary in my family because I insisted on returning to see "my" painting week after week. I fell in the thrall of that image, with its sky that seemed endless

SONG OF THE LARK
Jules Breton
Oil on canvas, 1884
The Art Institute of Chicago, Chicago

to me, and the particular quality of the light that seemed filled with a kind of holy splendor. Those are words that I can say now, as an adult. When I was a small girl, what I told my mother was that it made me feel that I was in church. Actually, it did. And even though I was a little black girl in Chicago in the middle of this century, the girl in this picture seemed to breathe with the same spirit that filled me at certain moments. I felt calmer, larger, more open, from looking at her there in that "not important" painting that attained

such incredible importance for a great lady and for an ordinary child, and probably for many others. As I look at this picture now I can still connect to the girl, to the sky, to the light. And I am humbled.

The power of art, of sheer beauty, to engage, to compel, to connect to the largest realities, to silence everything outside, is something we have all experienced at one time or another, even if we don't talk about it. Some of us can paint or carve objects of power; others of us can see. All of us can know. ✦

Standing in the Way of Beauty

by Kenneth Baker

To say what beauty is may be more than we can do. But often we can be confident in saying where it is: in this face, in that landscape, in some favorite piece of music or art object. We tell someone where beauty may be found and trust them to know it when they see it, as we have.

Most of the time, beauty seems to be elsewhere: in some other place, at some other level of being than that which preoccupies us now or beyond what concentration we can summon at the moment. The feeling of surprise that often marks the experience of beauty is like an arrival: life has finally put something beautiful in our path, or something we have taken for granted has finally shown us its beautiful side.

The beautiful typically seems to be at a distance, and our discovery of it has the quality of a real or metaphorical journey. Institutions like the Miho Museum exist partly for the same reason that many great art objects themselves are treasured—to reassure us that there are fixed places where beauty may always be found.

But museums and art objects answer only partly the riddle of why beauty seems almost always to be at a distance from us. For me, one particular work of contemporary art held the answer to this question: *The Lightning Field* by Walter De Maria.

The Lightning Field is a work of "land art," completed in 1977. Located at a remote point in the high desert of New Mexico, it is both a place and a constellation of things. Of almost everyone who sees it, it demands a considerable journey. Most people come to it by way of Albuquerque, which has the only large airport in the state of New Mexico. To reach *The Lightning Field* from Albuquerque by car takes about three hours. For the final leg of the trip, visitors must be met by one of the caretakers of the piece and driven the last 25 miles of unpaved road to the site. A typical visit involves arrival in early afternoon, an overnight stay in the cabin that adjoins *The Lightning Field* and departure the following morning. Few works of art demand such time and commitment of their viewers, but there are good reasons why this one does.

The peculiar circumstances of my involvement with this work have given me special access to it from the outset. In early 1978, the Dia Art Foundation (now known as Dia Center for the Arts), which constructed the work, commissioned me to write a long essay about *The Lightning Field*. As a consequence, my wife and I were among its first visitors, before Dia had even decided how to make it public. Since then, I have made five more visits, lasting between two and ten days. (The commissioned essay, though still unpublished, will be part of the monograph on *The Lightning Field* that I am completing for the University of California Press.)

My crucial realization concerning beauty occurred during my first trip to *The Lightning Field*. Succeeding visits have confirmed it. Before departing from New York in March 1978, I knew only that *The Lightning Field* consisted of 400 vertical stainless steel poles arrayed in a grid that covers a mile-by-kilometer area of desert. Nothing prepared me for the difficulties of travel to the site nor for the experience that awaited me there.

"I take SPACE to be the central fact to man born in America," the poet Charles Olson wrote in his book about Herman Melville. "I write it large because it comes large here, large and without mercy." Olson might have been introducing *The Lightning Field*. The effectiveness of *The Lightning Field* as a work of art depends upon its isolation and therefore on the immensity of the American continent.

A city-dweller's first visit to the Southwest is always a shock. The immense sky, the dazzling light and the shadowless openness of the terrain abolish one's ability to estimate distance and travel time. The New Mexico landscape has frequent moments of grandeur. But it creates less a sensation of beauty than of the sublime. The sublime is a concept central to 18th-century European aesthetic thought. It names the powerlessness we feel when we are struck by the scale and force of nature. Rather than contradict the overall sublime aspect of the enveloping landscape, *The Lightning Field* wrests from it an elusive but crucial revelation about beauty.

The Lightning Field is normally open to visitors only during the relatively dry summer months. That this happens to be the lightning season matters less than the fact that whenever it rains there, the ground turns to gluey, slippery mud. Driving becomes treacherous even for people familiar with the unpaved roads, and walking can be exhausting. The high elevation of the site—7,200 feet above sea level—causes many visitors to feel short of breath at first.

Today, the country roads peripheral to the area of *The Lightning Field* are surprisingly well-maintained. But on my first visit in 1978 they were not. A few miles off the highway that runs west from Albuquerque, the road became a slough of mud. We skidded and bounced through mud ruts and pond-size puddles for almost three hours before the

Following page
THE LIGHTNING FIELD
Walter De Maria
1977
LF-61
Photo: John Cliett
Courtesy Dia Center
for the Arts

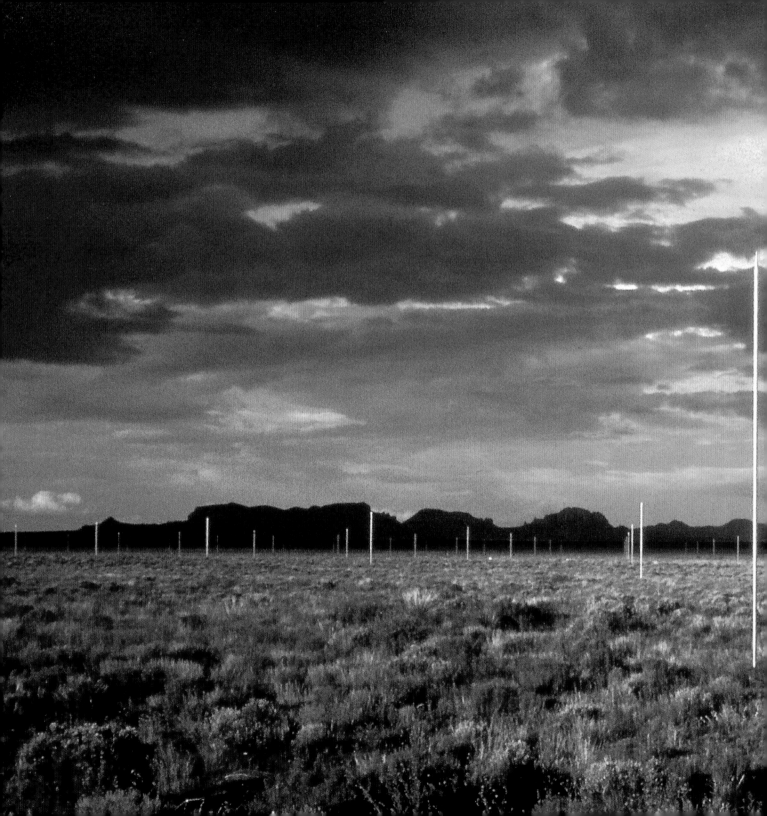

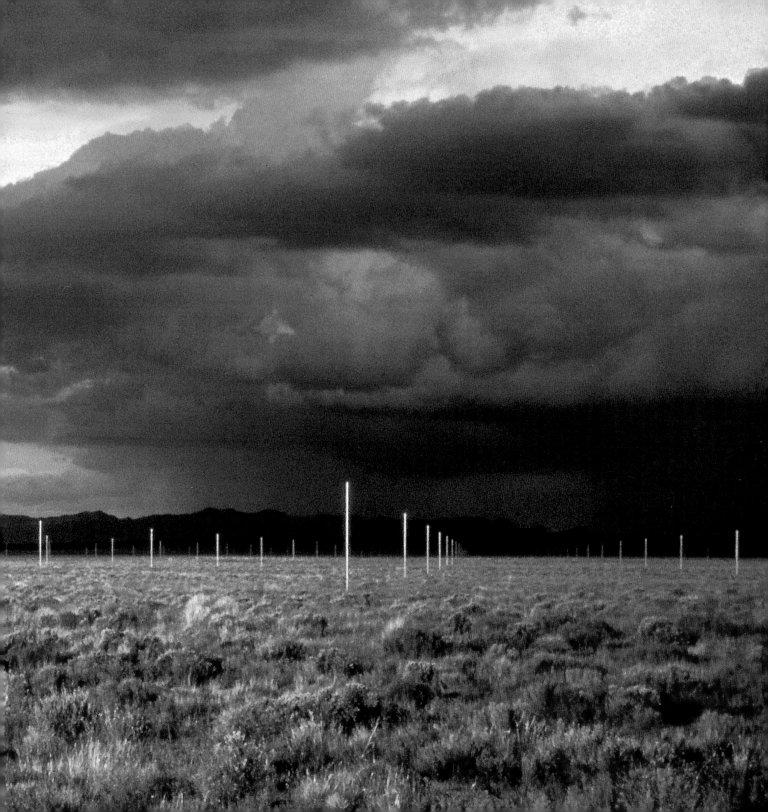

cabin at *The Lightning Field* finally came in sight. Once we left the highway we saw no other dwelling and only one passing vehicle on the entire trip.

The cabin was built in 1918 by a homesteader who abandoned it a few years later, having found the land unsuitable even for subsistence farming. Dia bought the cabin with the land and refurbished and expanded it. The cabin remains rough in appearance, but it does now have electricity, a working kitchen and indoor plumbing. And its walls are sealed against the relentless desert winds. In March 1978, the cabin's only amenities were a wood stove and a bed. Conditions then made arriving at *The Lightning Field* like going back in time. Visitors today still have a taste of that feeling, but electric light, appliances and running water cushion them against it.

The journey to the site does still enforce one key experience, especially on a first visit: the sudden withdrawal of the familiar world and one's connections to it. There is no telephone, television or radio. How one would learn of a calamity "back in the world" is a question that seems to ring not only in one's mind, but in the extraordinary silence of the desert itself.

The sky was overcast when we first arrived, at about four in the afternoon. The 400 poles of *The Lightning Field*—which sound so imposing when one imagines them in an urban or interior space—were barely visible. They appeared fine as needles and were far more spread out than I had imagined. Each pole is 220 feet from the next. They are aligned in a grid of seemingly impossible precision—the eye can detect no flaw in it—and under some conditions they seem to extend farther than the eye can see. Walking the entire mile-by-kilometer perimeter is the only way to satisfy oneself of the grid's true size. It seems to expand or shrink with changes in the light and weather.

I quickly set out into the array on foot, barely heeding the caretaker's warning that it would get very dark very quickly on such a day. When night did fall, I was at least half a mile from the cabin. Only a candle in the window enabled me to find my way back. Each pole, I discovered, is a stainless steel cylinder, two inches in diameter, that tapers to a sharp point at the top. The poles all rise to the same height: their tips define a plane parallel to sea level. Accordingly their lengths vary with the land elevation, from about 16 to 26 feet. They do indeed look like lightning rods, not only in form, but in the way they seem to taunt the sky, to defy nature to answer their probing address to it. Despite the work's title, lightning striking at *The Lightning Field* is far less meaningful than the unbeckoned realizations that strike the alert visitor there.

Each pole rises from the ground as if growing there. The shock of seeing them spring from the earth echoes an image burned into the American imagination by Cold War terror: the image of missiles rising from their silos beneath the Great Plains of the West. (Many of the ICBMs are still there, though they are supposed to be disarmed of their nuclear warheads or no longer maintained in the hair-trigger status of former great power confrontation.) The poles set up a psychological polarity: their unmistakably contemporary, perhaps even futuristic, quality is in constant tension with the timelessness of the desert. When one gazes at the mountain horizons, they give no clue what time it is historically; the poles remind us in an instant.

The Lightning Field poles give structure to the open space of the plain, or to the quadrant of it that they delineate. They are like a pure projection of the rational mind upon the organic disarray of the desert floor. So it is they, not the cabin, that seem like true surrogates of the absent world. In their cold precision, they are perfect tokens of a world whose lifeblood

is technology: our world. In fact, *The Lightning Field* suggests to many people some "big science" instrument whose function laymen cannot guess, or are not meant to guess.

Most visitors to *The Lightning Field* feel it to have an apocalyptic tone. The longer one stays there, the more the remoteness of the world becomes psychologically equivalent to its historical aftermath and the more the poles suggest themselves as remains of a world undone by the very technology that formed it. This thought came very readily to mind in the Cold War years, when the danger of nuclear calamity was a conscious fear shared by almost everyone. That fear has abated now that the Cold War is over, but *The Lightning Field* still holds the revelation that it held for me: that consciousness of history is what makes beauty seem unavailable to us now. Mindfulness of history — of the injustices committed and the wars fought in our names, including humanity's ongoing war on nature

—makes us feel helpless. But it feels to us like a form of moral vigilance that we dare not relax lest we fail to see what might be done to avert yet worse nightmares than the 20th century has already seen. Attention to beauty seems to entail a slackening or denial of historical awareness that feels unconscionable. We know that our only power to affect events may be the power to bear witness, so averting our awareness seems like a lapse of duty.

The Lightning Field made this point clear to me. More important, it showed me how beauty may in fact be the way past the paralysis of historical consciousness.

On my first day, I managed to walk far enough west of the cabin, under the thickly clouded sky, so that when the setting sun broke through I saw its light hit perhaps two thirds of the silver poles at once. I realized then that the poles are cylindrical mirrors that condense the light that falls upon them. When the light is vertical or dim, their presence is

THE LIGHTNING FIELD
Walter De Maria
1977
LF-14
Photo: John Cliett,
Courtesy Dia Center
for the Arts

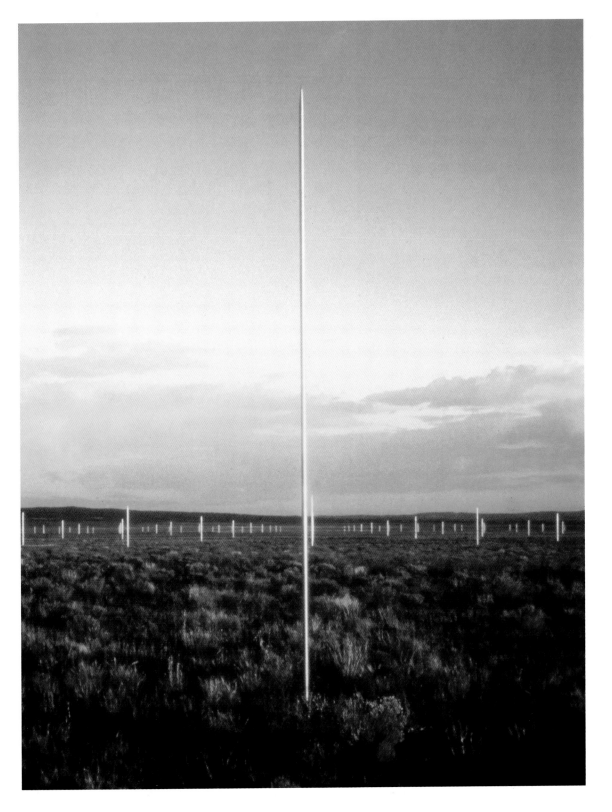

faint, but when the sky is clear and the sun near the horizon at morning or evening, the poles become blazing columns of reflected light, hanging in space. A breathtaking vision that no description or photograph can convey, it lasts until the light fails at day's end, or until the morning sun rises too high.

Seeing the poles in their full efflorescence has two important effects. It causes us to see them as mirrors of our own being — as creatures that flare into existence, shine briefly, then disappear. This vision chimes with the sense of oneself as a tiny, fugitive creature on a fertile, spinning planet: the vision that the landscape itself imposes.

The second effect of seeing *The Lightning Field* ablaze is to understand what it is to see the beauty of the world: it is to see things as radiant with their being. More traditional works of art that we see as beautiful effect this sense of radiance through inspired conception, the perfection of craft, or both. *The Lightning Field*

does it by compelling us to align ourselves with the light — as if we could become its source. (As Norman O. Brown says somewhere, "love without attachment is light.")

At one level, *The Lightning Field* materializes a pessimistic historical consciousness: a striving for technical perfection and power that will sacrifice anything, even the earth, to fulfill itself. This is our vision, the work implies, ours by dint of having lived in the 20th century. That is why, though we may try to repress this vision, we cannot truly look away from it.

What *The Lightning Field* offers us is proof that we can have intense experiences of beauty without denying the reality of our situation. *The Lightning Field* itself is a prime instance of such an experience. It is an instrument for intensifying our attention to the realities even to all that we see as markers of history — until we can learn to see them as radiant with their being at every moment. Only that vision liberates the present moment from the shadow of history's

determinism. Whatever may happen, we are reminded, the world has not destroyed itself yet, death has not come to it or to us yet. With that thought we recognize this moment of consciousness — in principle, any moment — as the highest possible privilege.

We need works of art, the ones we consider most beautiful, to remind us that this wide-awake embrace of being is possible and what it feels like. Beauty is ordinarily at an inestimable distance from us because we are typically so far from this state of awareness. 🜲

Ancient Fragments Inspire a Career

by Yutaka Mino

Before going to Egypt when I was a junior in college in 1963, an incredible opportunity came to me through the most well-known scholar of Chinese ceramics at that time, Professor Fujio Koyama.

I heard that Professor Koyama was planning to go to Egypt to investigate Chinese ceramics that had been unearthed in Fustat near Cairo. The government of Egypt had asked him to study them.

He already had planned to work with an Egyptologist, Mr. Suzuki, who was living in Cairo; Tsugio Mikami from Tokyo University, specializing in Oriental Archeology; and Gakuji Hasebe, a curator with the Tokyo National Museum.

Then I went to meet Professor Koyama, whom I had never met before. I asked him if I could join the expedition and told him I would do my best. Fortunately, he gave me the opportunity to join in the work.

The expedition started in January 1964, while I was a college student. It was the time of final exams. I went to a professor from whom I was taking courses and asked him to give me the grade for his course, because I wanted to join the expedition. I convinced him that the expedition would be equal to taking the exam for his course. Fortunately, he gave me the grade, and I was able to get credit for the year.

From the first day, the trip was to change my life. As I stood at the site, I thought about a thousand years of people creating beautiful ceramics, even though they were all fragments now. Thinking about that long history made me want to study Chinese ceramics.

As we collected fragments of many types of ceramics, I chose to study only the Chinese fragments from the mountain. We dug up over a thousand ceramic objects, ranging from the ninth century to the 18th-century, mainly celadon wares and blue-and-white wares. It was the most exciting project.

It was also a fascinating experience to learn about the trade and the production of ceramics, all of which were copied from the Chinese. That is the reason why scholars want to collect Chinese ceramics.

We were in Egypt for over one month, and I was abroad for about four months. After the project was over, they gave me $500 to travel around the world. I visited mostly museums in Europe and the United States, and found many ceramics in U.S. collections. By that time, I had already decided someday to study Chinese ceramics in North America.

When I was traveling in Istanbul, I went to see the Topkapi Saray Museum, in which there are famous Chinese ceramics. I found a vase there that contains shards that were similar to the fragments I had excavated in Fustat. Then I also found a large flask vase at the Percival David Foundation in London that also has shards of exactly the same design. That piece is from the Yongle reign (1403-1424) during the Ming Dynasty. I was very fascinated with this flask. I found three more similar flasks. One is in the Ardebil shrine, Tehran, the second one is in the Palace Museum, Beijing, and the last one is in Hatakeyama Museum, Tokyo.

The shape of the flask vase originated from the metallic lamp that is hung in the ceiling of a mosque. This shape is rare for Chinese ceramics. It was adopted because an order had come

Left
FRAGMENTS OF CHINESE BLUE-AND-WHITE WARE
Fustat, Egypt

Right
VASE
China, Ming Dynasty
Yongle Reign (1403-24)
Topkapi Saray Museum, Istanbul

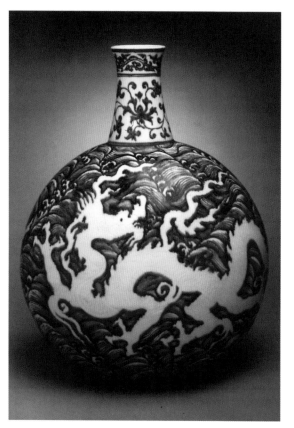
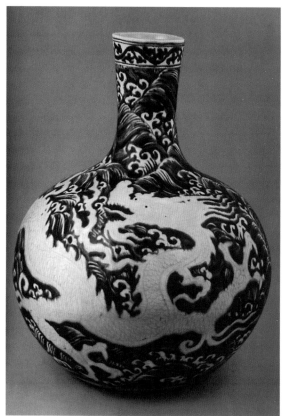

from the Near East for vases to be exported there. In the Near East, the vase was used for tea, and had a top made of silver. These vases were made in the Jingdezhen kilns and were shipped from harbors in the Fujian Province.

It was very exciting for me to trace the many places the vases had passed through and to think about the thousands of miles they had traveled. Some ships could not make the journey and many sunken ships contain Chinese blue-and-white porcelains. Some have been found off the east coast of Africa. It must have been very difficult to travel in olden times.

I have very special feelings about the fragments from Fustat and the Chinese vases from the early 15th-century that brought me into my current career. From a fragment, I have traced the route of a Chinese ceramic vase across the Near East, Europe and the U.S.

After the expedition, I had a strong desire to understand more about Chinese ceramic wares, so after I graduated from college I went to work with an art dealer who specialized in Chinese ceramics in Tokyo. I worked there for three and a half years, during which time I became a true connoisseur of ceramics.

Professor Koyama, who took me to Fustat, then asked me to go to Toronto to continue my studies. I worked as a curatorial assistant in the Royal Oriental Museum in Toronto for two years, and published "An Index to Chinese Ceramic Kiln Sites: From the Six Dynasties to the Present" in 1973. I decided to pursue a Ph.D. at Harvard and study with professor Max Loehr. I wrote my doctoral thesis on "The Development of Tz'u chou Type Wares."

The small blue-and-white 15th-century fragment that was found in Fustat, Egypt, helped to enlighten me. That's where my career started. ✿

Left
FLASK VASE
China, Ming Dynasty
Yongle Reign (1403-24)
Percival David
Foundation, London

Right
FLASK VASE
China, Ming Dynasty
Yongle Reign (1403-24)
Palace Museum, Beijing

Following Page
FRAGMENTS OF CHINESE
CELADON WARE
Fustat, Egypt

Contributors

Kenneth Baker

Mr. Baker is currently the art critic for the *San Francisco Chronicle*, as well as a freelance contributor to numerous publications, including *Smithsonian* magazine and *Architectural Digest*. He has also been the art critic and a contributing editor for the *Boston Phoenix*. In addition to his writing contributions, Mr. Baker has taught at the School of the Boston Museum of Fine Arts, Stanford University and the San Francisco Art Institute. His guest lecture appearances include Boston University and the University of Massachusetts, as well as the University of California, Berkeley and the University of Texas. Mr. Baker received his B.A. in art history from Bucknell University. He is currently writing a monograph on Walter De Maria's *The Lightning Field* and a critical profile of John Cage, both to be published by the University of California Press. He is a member of the International Association of Art Critics and the National Book Critics Circle.

Gabriele Czöppan

Ms. Czöppan is the senior art critic for the German newsmagazine *Focus* for which she writes reviews, portraits and articles on such subjects as "Kandinsky and the 'Blaue Reiter'," the Venice Biennial, the Whitney Biennial, Andy Warhol, Jackson Pollock and Gerhard Richter. She has also been a co-host of two one-hour specials on Markus Lupertz and Alfred Hrdlicka produced by West German Television. Ms. Czöppan has also served as arts editor for the art magazine *PAN* published by Burda publications for which she contributed articles on Jonathan Borofsky, Wofgang Laib, Vincent

van Gogh, Henri Toulouse-Lautrec, the Kimbell Art Museum in Fort Worth, Texas, the J. Paul Getty Museum in Malibu, California, the Courtauld Institute in London and the Castello di Rivoli in Turin. She began her career working for the Austrian Television and Radio Broadcasting Station ORF and has also published art reviews for the art magazine *Kunstform International*, *Sueddeutsche Zeitung* and the widely circulated *Abendzeitung*. Ms. Czöppan studied journalism, German literature, sociology, politics and art history at the Ludwig-Maximilians University in Munich, Germany. In 1998 she was one of the speakers for a panel organized by the Congress of Psychoanalysis of the GFF in Speyer, on "Art and Healing."

David Finn

Mr. Finn is chairman and CEO of Ruder·Finn, Inc. a global public relations firm with a special department, Arts and Communications Counselors, that works for major cultural institutions and arts programs. He is a writer and photographer, primarily of sculpture. His books have been devoted to works from different periods of history, including ancient Egypt, classical Greece and Western art from the 12th–20th centuries. He has also published books on individual sculptors including Claus Sluter, Donatello, Michelangelo, Cellini, Giambologna, Bernini, Canova, Rodin and Henry Moore. Mr. Finn's photographs have been shown in exhibitions at the Metropolitan Museum of Art in New York; L'Orangerie in Paris; the American Cultural Center in Madrid; the Art Gallery of Toronto; the Yale Center for British Art in New Haven, Connecticut; and in

galleries in New York, Chicago and London. Mr. Finn is a member of the National Trust for the Humanities, and a fellow of the American Academy of Arts and Sciences. He is a board member of the Academy of American Poets, the American Forum for Global Education, MUSE Film and Television, the Business Committee for the Arts, and Cedar Crest College.

Ronne Hartfield

During the past decade Ms. Hartfield has been the Woman's Board Endowed executive director for Museum Education at the Art Institute of Chicago during which time she determined the character of the museum as an education institution, organizing and administering all aspects of the department. Ms. Hartfield has also been dean and professor of comparative literature at the School of the Art Institute of Chicago. She has served on the Advisory Boards of the British American Arts Association, Harvard University Graduate School of Education, Chicago Symphony Orchestra and the Hastings Foundation, as well as a consultant to the National Endowment for the Arts, the U.S. Office of Education and the Kennedy Center in Washington, D.C. She is a member of the International Council of Museums and the National Association of Local Arts Agencies. A winner of the Sidney Yates Award for Outstanding Contributions to the Arts, she consults widely and is an internationally recognized expert in arts education. Ms. Hartfield earned undergraduate and graduate degrees from the University of Chicago in history, theology and literature.

Thomas M. Messer

Mr. Messer's distinguished career includes being a professor at the Johann Wolfgang Goethe University, Frankfurt, Germany, the former director of the Institute of Contemporary Art, Boston as well as director emeritus of the Solomon R. Guggenheim Foundation in New York City. He has been the chief curator of the Schirn Kunsthalle, Frankfurt, Germany; an adjunct professor at Harvard University; and a professor at the Hochschule fur Angewandte Kunst, Vienna, Austria. He is also a founding member of the American Arts Alliance, Washington, D.C., and served as president of the MacDowell Colony Inc. He is presently a Trustee of the Fontana Foundation, Milan and a former member of the Advisory Board for Palazzo Grassi, Venice. Mr. Messer has been decorated as a Chevalier, Légion d'Honneur, France and is an Officer of the Légion d'Honneur. He is also the recipient of the Goethe medal from the Federal Republic of Germany. An author of books on Edvard Munch and Vasily Kandinsky, Mr. Messer is also a contributor to museum catalogues and art journals. His education includes a B.A. from Boston University, a degree from the Sorbonne and a M.A. from Harvard University.

Yutaka Mino

Dr. Mino has served as the director of the Osaka Municipal Museum of Arts since 1996 and is a former director of the Asian Art Department of the Art Institute of Chicago. His life has been dedicated to the study of Asian art, as well as an indefatigable quest to share his devotion to Asian art with the public. In the capacity of

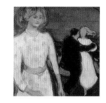

curator, he has overseen the organization of numerous successful exhibitions that were well received by the public. Dr. Mino has served as a professor at the Musashino Art University in Tokyo, the University of Michigan and the Keio University in Tokyo. He has also published numerous articles on Asian art in a wide variety of publications. Presently, he is a trustee of the Oriental Ceramics Museum, Osaka and serves on the acquisition committee at the Osaka Modern Art Museum, as well as on the steering committee at the National International Art Museum, and on the standing committee of the Oriental Ceramics Society. Dr. Mino has been awarded the Koyama Fujio Memorial Prize (1981) and the Chicogoana of Arts (1992). He received his B.A. in art history from Keio University and a Ph.D. from Harvard University.

Lika Mutal

Ms. Mutal was born in the Netherlands and studied at the Lyceum in Utrecht. She moved to Peru in 1968 and studied sculpture at the Academy of Fine Arts at the Catholic University. In 1972, she began to work in stone and established herself in a small studio to work and study exclusively in this material. She came into contact with Peru's eminent stone carvers with whom she studied carving. Her early exhibitions took place in Lima and her first European show was in 1974. Subsequently, she has exhibited at the Kröller-Müller Museum in the Netherlands, which acquired some of her works in 1978, and her works have been shown in Paris at the Galerie Daniel Gervis, as well as at the Foire Internationale d'Art Moderne et Contemporain en Europe (1980). In 1984, her works were shown at the Nohra Haime Gallery in New York City. In 1992, she won international recognition in Japan and in 1996 a book on her sculpture was published by Harry N. Abrams, Inc. Ms. Mutal's works are part of numerous corporate collections.